IMAGES
of America

GREATER BOSTON
COMMUNITY THEATER

EASTERN
MASSACHUSETTS
ASSOCIATION
OF COMMUNITY
THEATERS

upport ◆ Recognition ◆ Education ◆ Celebration ◆ Community!

The Eastern Massachusetts Association of Community Theaters (EMACT) was founded in the late summer of 1985 by an emergency gathering of individuals concerned with the cancellation of an annual community theater festival, which had run uninterrupted since 1954. The organization worked closely with New England Theater Conference (NETC), then the festival hosting organization, to assure that the festival continued until such time as EMACT could take sole sponsorship. By 1992 the organization was ready to transition sponsorship of the annual drama festival and completed the task in 1993. The festival continued at the Spingold Theater on the campus of Brandeis University until 2003, when it was moved to its new location at Babson College. EMACT is part of the American Association of Community Theatre (AACT). The purpose of EMACT is to foster and encourage all community theater activities in Eastern Massachusetts, such activities as education, support, and communications and networking. Proceeds from the sale of this book will go directly to EMACT to support it in its benevolent mission.

On the cover: Shown is a cast picture of *Death Takes a Holiday*, a Winthrop Playmakers Production in the 1950s. From left to right are Anne Hey, Richard Lindsey, Vargie Berry, Jean Canton, and Dimetrio Vasel Tearmont. (Courtesy of the Winthrop Playmakers.)

IMAGES
of America

GREATER BOSTON
COMMUNITY THEATER

Judson Lee Pierce

ARCADIA
PUBLISHING

Published by Arcadia Publishing
Charleston SC, Chicago IL, Portsmouth NH, San Francisco CA

Printed in the United States of America

Library of Congress Catalog Card Number: 2006925713

For all general information contact Arcadia Publishing at:
Telephone 843-853-2070
Fax 843-853-0044
E-mail sales@arcadiapublishing.com
For customer service and orders:
Toll-Free 1-888-313-2665

Visit us on the Internet at www.arcadiapublishing.com

*Dedicated to my son, Benjamin Ryan Pierce,
and to the sons and daughters of us all. May you imagine and delight in
all that is artistic and beautiful in this world.*

CONTENTS

ACKNOWLEDGMENTS

This book is meant to depict the history of community theater in the Greater Boston area from 1877 up through the new millennium. It is not meant to be complete or to encompass all organizations and people. The author wishes to apologize, in advance, for any errors of fact or omission.

The 2005–2006 EMACT board of directors has been helpful in countless ways since the evening of my first board meeting in the summer of 2005 when I spoke about this project. I am grateful to them all: Celia Couture, president; Douglas Cooper, vice president; Susan Latiff, secretary; Susan Condit Rice, vice president of services; Sandy Armstrong, vice president of education; Julie Ann Govang, vice president of festivals; Anne Damon, treasurer; and Jean MacFarland, membership.

There are several people who have paved the way for this book through their research, photographs, writing, experiences, and enthusiasm for community theater. Specifically I wish to thank Michelle Aguillon, John Barclay, John Barrett, J. Mark Baumhardt, Thomas Berry, Leigh Berry, Carolyn Bingham, Paul Campbell, Donna Corbett, Dr. Guy Dillaway, John Fogle, Harriet Friedman, Lori Lord, Margaret McCarty, Beryl Noble, Donald Oliver, Rick Pierce, Pamela Racicot, Edward Racicot, Nancie Richardson, Donald Richardson, Daniel Romard, Dorothy Schecter, and Dave Sheppard.

I am deeply grateful to the following theater companies and their Web sites, which provided me a great deal of information: Acme Theater, Arlington Friends of the Drama, Belmont Dramatic Club, Concord Players, Footlight Club, Hovey Players, Marblehead Little Theater, Mugford Street Players, Newton Country Players, Quannapowitt Players, Theatre III, Vokes Players, Wellesley Players, Weston Friendly Society, and Winthrop Playmakers.

I wish also to express my particular indebtedness to the following published works about community theater and American life: *The Stuff of Dreams* by Leah Hager Cohen, *The Community Playhouse* by Clarence deGoveia, *Let There Be Art* by Twink Lynch, and *For Common Things* by Jedediah Purdy.

For the design, editing, and production of this book I gratefully acknowledge the work of Arcadia Publishing, specifically my editors Erin Stone and Kaia Motter.

I wish to thank my family and all my other teachers. And with all my heart I thank my wife, Laura, who took part every step of the way and always to the benefit of the work and the author.

INTRODUCTION

*Through depression and war and the advent of television
and computers and commuters and all manner of social and economic change,
a few people have continued, against reason, to want to make theater.*

—Leah Hager Cohen, *The Stuff of Dreams*

Community theater offers our American society a chance at renewed attention to the "common things" we all have a stake in. It has the best chance of reaching the average citizen and family, and it represents a shared goal among people of various ages and backgrounds. It survives for the good of the community and is a positive force in civic life. It is democracy prompting public participation and hard work and thrives on support from a cross section of our community. The people past and present who have contributed to this endeavor are heroes to the community.

The geographical area around Boston has for years been blessed with numerous quality community theaters. Many of the oldest continually running community theaters in the United States are in this area, and many others are growing and just coming into existence in the present time. What are the reasons that local theater has taken such a hold in this area of the United States and what are some of the ways that we as a society can keep it alive are two of the questions that this book aims to respond to.

To fully address these questions one must understand what theater is and what it aspires to be. The community theater movement has always been about hard work and cooperation. There is much to be done in the production of a play that the audience does not readily appreciate. From start to finish, a community theater will have spent hundreds of hours on any given production from the play reading committee selecting the piece and its director, to the casting committee selecting the actors, to the director and producer collaborating on a backstage crew and designers, to the crew and designers assembling the set, lighting, and sound, through the rehearsal process and actual performances themselves.

Community theater, as is the case with American society, strives for a balance between the goals of the individual and the goals of his or her fellow actors and crew. For the individual, it allows one to continue with their dreams of performing, pursuing a passion in theater, while carrying on the day-to-day work life they have chosen. It allows someone to create something new and provides a positive force for self-confidence. For the team, participating in theater fosters the sense of being part of a "family," everyone working together for the common good, creating new friendships along the way. For the community at large, local theater offers entertainment, education, and enlightenment. This incredible opportunity to impact our communities brings a responsibility with it as well, as community theaters ought to be accountable to the ideal of theater as an art form and not just a form of recreation and social interaction. The Arlington Friends of the Drama mission statement, written in 1934 when it was recognized as a legal corporation, states best what community theater strives to accomplish: "To enlighten and educate the public concerning the value of the theatre as a vital factor toward the higher development of dramatic

art and to establish a permanent playhouse in the Town where the best plays of all times may be presented, where competent actors may be afforded an opportunity of appearing before the public under favorable conditions and to encourage playwrights and actors in the best traditions of the dramatic profession."

This book honors those who, over the past 130 years, have continued in the best traditions of the dramatic profession. For they are those who arrive "from days spent as office workers and welders, bookkeepers and bakers, tutors and homemakers and being asked to step up and bare themselves, to play make-believe with strangers, in front of other strangers, out of context."

One

LADIES WILL PLEASE REMOVE THEIR BONNETS
1877–1919

Pictured here is the Footlight Club list of plays from 1877 to 1879. In December 1876, a group of young people, with Caroline Morse as the guiding spirit, met in Jamaica Plain, a suburb of Boston, to consider launching an amateur theatrical organization. The Footlight Club formally came into being, as an unincorporated association, on January 4, 1877. And just five weeks later the first performance took place in the old German Theater in Boston. The club has been in continuous operation ever since. That first production—*A Scrap of Paper*—was repeated as the 25th production in 1882 and again as the club's 100th in 1906.

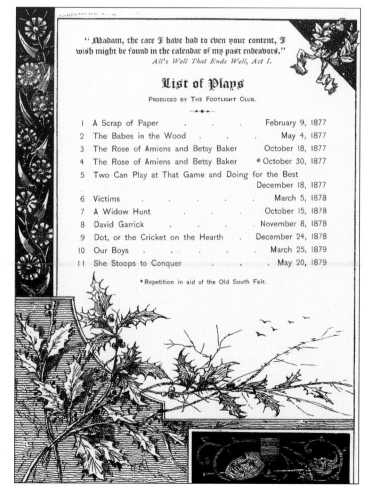

" Madam, the care I have had to even your content, I wish might be found in the calendar of my past endeavors."
All's Well That Ends Well, Act I.

List of Plays
PRODUCED BY THE FOOTLIGHT CLUB.

1	A Scrap of Paper	.	February 9, 1877
2	The Babes in the Wood	.	May 4, 1877
3	The Rose of Amiens and Betsy Baker		October 18, 1877
4	The Rose of Amiens and Betsy Baker		*October 30, 1877
5	Two Can Play at That Game and Doing for the Best		December 18, 1877
6	Victims	.	March 5, 1878
7	A Widow Hunt	.	October 15, 1878
8	David Garrick	.	November 8, 1878
9	Dot, or the Cricket on the Hearth	.	December 24, 1878
10	Our Boys	. .	March 25, 1879
11	She Stoops to Conquer	.	May 20, 1879

*Repetition in aid of the Old South Fair.

BY-LAWS

OF THE

First Parish Friendly Society

The Weston Friendly Society of the Performing Arts, Inc., was organized on January 12, 1885, and has a rich history of putting on quality productions for enthusiastic audiences from all over the state. The Friendly Society originated as a forum for group readings of classic books, poetry, and the Bible in a small theater on the estate of Horace Sears. Pictured here is the title page of its bylaws from 1885.

I. The name of this Association shall be THE FIRST PARISH FRIENDLY SOCIETY, of Weston.

II. Its object shall be to encourage social relations among members and friends of the First Parish of Weston, and to promote the growth and prosperity of said First Parish.

III. The members shall consist of such persons as shall be approved by a majority of the Council and shall assent to the By-Laws, but application for membership must be made to the Secretary in writing, and signed by the applicant.

IV. The officers of the Society shall consist of a President, two Vice-Presidents, a Treasurer, a Secretary, and an Executive Committee of three members, who, together, shall constitute a Council for the control of the Society. They shall be elected at the annual meeting, and shall hold their offices for one year, or until their successors are chosen. They shall have authority to fill vacancies in their number for the unexpired term.

V. Members must accept, unless excused by the Council, any office or committeeship in the Society to which they may be elected, or else forfeit their membership. But no member shall hold the same office for more than two consecutive years.

VI. The annual meeting shall be held on the fourth Monday of March, in each year. Special meetings may be called by the Council at its discretion, and shall be called on the written application of seven members. Announcement made during the Sunday morning church service of any meeting to be held, shall be considered sufficient notification to all members.

VII. An initiation fee of fifty cents shall be required. An annual assessment of fifty cents shall be levied by the Council upon every member in April of each year. Other assessments may be laid upon recommendation of a majority of the Council and by a vote of two-thirds of the members present at a meeting held after one notification that such action is contemplated.

VIII. Any member whose annual assessment is not paid within sixteen months from the time at which it becomes due (proper notice having been given by the Treasurer) shall forfeit his or her membership. The Council shall have power, by a majority vote, to expel, or suspend for a stated time, any member of the Society.

IX. Nine members of the Club shall constitute a quorum for the transaction of business.

X. At the annual meeting in each year, the Council shall make a written report of the condition of the Society, the state of its finances, and other items of interest.

XI. These By-Laws may be altered or amended by a two-thirds vote of the members present at a meeting regularly called, provided notice of such intended change shall have been given at the previous meeting.

The Weston Friendly Society eventually migrated to performing cabaret style in Weston Town Hall, a tradition that is alive today. Historically society membership was limited to only Weston residents connected with the First Parish Unitarian Church. Today membership is non-sectarian and is open to all residents of metropolitan Boston and beyond. Shown here are the 1885 Weston Friendly Society bylaws 1–11.

Pictured here is the title page of the organizational records of the Weston Friendly Society. Despite changes in membership since 1885, the original purpose of the Weston Friendly Society has been steadfastly maintained: "The Friendly Society is a self-supporting, non-profit performing arts organization which promotes community service and fellowship through support of local charitable causes."

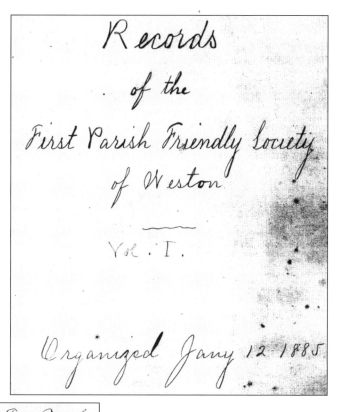

Records of the First Parish Friendly Society of Weston.

Vol. I.

Organized Jany 12 1885.

All members of the First Parish interested in forming a social organization were invited to meet at the house of Mrs. E. H. Sears on Tuesday evening, Jan 12, 1885. The following ladies and gentlemen were present:—

Mrs Charles F Russell. Mrs E O Clark. Mrs Robert Winsor. Miss Hattie S Perry. Miss Anna C Coburn. Miss Alice E Jones. Miss Edith S Coburn. Miss Gengiana Buchanan. Miss Hattie Sanderson. Miss Ellen M Jones. Mr Horace S Sears. Mr Robert Winsor. Mr William H Coburn.

After considerable informal discussion Messrs Winsor and Sears, Mrs Russell and Miss Perry were appointed a committee to retire and report a name for the proposed society with a list of officers and a plan of operations for the ensuing months They duly reported as follows

For a name — The First Parish Friendly Society

Pictured here is the first page of the organizational records of the Weston Friendly Society. Listed here are members of the First Parish interested in forming a "social organization" who met at the house of Mrs. E. H. Sears on Tuesday evening, January 12, 1885. The organizational name they came up with was the First Parish Friendly Society. "Friendly" harks back to a title given to community-based groups in England. In the beginning, plays, dramatic readings, and chamber music programs were produced and held in a small theater called Haleiwa on the estate of Horace Sears, whose name graces the society's home theater at the Weston Town Hall.

List of Officers

President	Horace S. Sears
Vice President	Mrs. E. O. Clark
Treasurer	Robert Winsor
Secretary	Ellen M. Jones

The following entertainments under charge of the respective committees were recommended:—

In the early part of February an Old-Fashioned Supper.

Committee

Mr. Henry S. Brown — Chairman

Miss Lizzie Stearns Miss Hattie S. Perry

Miss Georgiana Buchanan Miss Edith S. Coburn

Miss Alice E. Jones Mr. Frank H. Cutter

Mr. William H. Coburn

In April and May two Theatrical Entertainments

Committee

Mr. Robert Winsor

Miss Annie C. Coburn Mr. Horace S. Sears

Shown here is another page of the organizational records of the Weston Friendly Society, listing its officers and committees: a grand supper planned for February and two theatrical committees. The Weston Friendly Society did in fact host a "Greate Supper" on Tuesday, February 3, 1885, "from earlie candle lyte, which is 6" until 8:00 p.m., and it was followed by a dance from 9:00 p.m. to 11:00 p.m. The cost of the event was "fiftie pennies."

July 4th An Entertainment.

Committee.

General J. F. R. Marshall.

Mrs. Charles F. Russell. Mrs. E. O. Clark.

Miss Ellen M. Jones. Mr. Arthur L. Coburn.

The report was adopted as submitted.

It was unanimously voted in the name of the society to subscribe $300. towards the proposed new church building.

Pictured here is the final page of the organizational records of the Weston Friendly Society. It shows the July 4th Entertainment Committee members, and it was unanimously voted to subscribe $300 to the new church building.

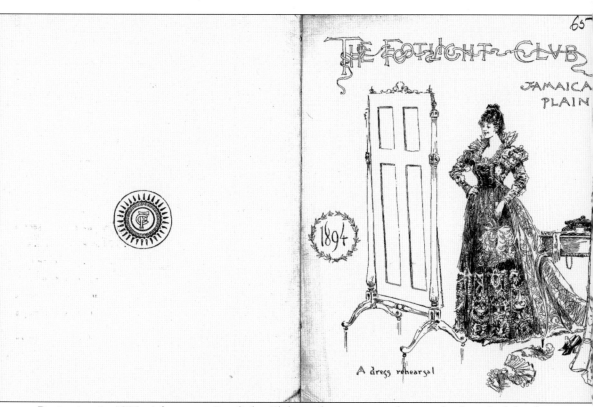

THE FOOTLIGHT CLUB

JAMAICA PLAIN

1894

A dress rehearsal

Beginning in 1890, tickets to a Footlight Club production carried not only the schedules for trolleys and steam trains back to the heart of Boston, but also the time that the final curtain would fall, implying that at least some members of the audience wanted to have their carriages standing ready to transport them. "Ladies are Requested to Remove their Bonnets" was also printed on the tickets—and still is. Pictured here is the current logo of the Footlight Club on its program for *The Dress Rehearsal.*

Program

ober 8 **Our Summer Visitors**

Mrs. MARY J. GIDDINGS. Mr. ARTHUR L. COBURN.
Mrs. ALBERT E. COBURN.

ober 22 . . **Women of the White House**

Miss ELIZABETH S. GOWING. Miss ELLEN M. JONES.
Miss SUSIE E. CUTTER. Miss GEORGINA BUCHANAN.

vember 12 . **Remedies for Social Discontent**

NATIONALISM . . . Mr. HENRY L. BROWN.
STRIKES . . . Mr. BRENTON H. DICKSON, Jr.
ARBITRATION . . . Mr. ROBERT WINSOR.

vember 26 . . . **An Evening of Music**

Mrs. GRANT M. PALMER. Mr. ALBERT H. HEWS.
Mrs. JOHN FULLER. Mr. FRANCIS H. HASTINGS.

ember 10 . . . **John Quincy Adams**

Mr. HORACE S. SEARS. Mr. LYMAN W. GALE.
Miss ANNA C. COBURN. Miss MATTIE W. TUCKER.
Mr. EDWARD FISKE.

ember 31 **Ghost Stories and Superstitions**

Miss L. E. EVANS. Mrs. ALBERT E. COBURN.
Miss ALICE E. JONES. Mr. HARRISON C. HALL.

uary 14 . . . **Social Evening**

Mr. CHAS. F. RUSSELL. Mr. F. WINTHROP BATCHELDER.
Miss EDITH L. COBURN. Mrs. ROBERT WINSOR.

January 28 **Our Magazin**

Mrs. ALBERT H. HEWS.

February 11 **Gladston**

Mr. FRANCIS H. HASTINGS. Mr. CLARENCE B. FLOYD.
Mrs. GEORGE N. STEDMAN. Miss FLORENCE M. COBURN.

February 25 *"of his Pudding"* . **On the Stag**

Mr. WILLIAM H. COBURN. Mr. CHARLES C. KENNEY.
Miss ALICE E. JONES. Miss ANNA C. COBURN.

March 11
Who shall succeed Tennyson as Poet Laurea

Mrs. F. WINTHROP BATCHELDER. Miss JANE WINSOR.
Mr. HARRISON C. HALL. Mrs. ALBERT H. HEWS.
Mrs. GEORGE ABERCROMBIE.

March 25 **Games and Gayet**

Mr. GEORGE ABERCROMBIE. Mrs. ALBERT H. SIBLEY.
Miss HARRIET S. PERRY. Mr. CHARLES H. FISKE, Jr.
Mr. CHARLES A. FREEMAN. Miss HELEN G. CUTTER.
Mr. GRANT M. PALMER.

April 8 **Future of the Negr**

Miss SUSIE E. CUTTER. Mr. ARTHUR L. COBURN.
Mr. LOUIS M. BRIGGS. Mrs. ERNEST D. LOVEWELL.
Mr. ALBERT H. SIBLEY.

April 22 **A Friendly Good-b**

Mr. ALBERT H. HEWS. Mr. GEORGE N. STEDMAN.
Mrs. CHAS. C. KENNEY. Mrs. HENRY J. JENNISON.
Mr. GEORGE S. PERRY. Mrs. EVERETT O. CLARK.
Mrs. LOUIS M. BRIGGS. Mrs. FRANK PERRY.

This is the program booklet for the First Parish Friendly Society of Weston for its season 1894–1985. The Weston Friendly Society has for over 120 years put the "community" into community theater by producing theatrical events to raise money for local charities.

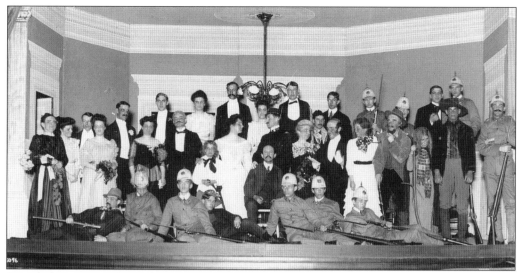

Founded in 1903, the Belmont Dramatic Club calls itself the second oldest continuously operating community theater group in the United States. Its distinction is that it did not stop performing even during wartime. It is a volunteer-run community theater based in Belmont, and it celebrated its 100th anniversary during the 2003–2004 season. Pictured here is a cast photograph of the second show, *Rosedale*, produced in 1904.

CAST OF CHARACTERS		SCENES

Act I. Rosedale Manor.
Act II. Room in Rosedale Manor
Act III. Matthew Leigh's Cottage
Act IV. Scene 1 — Room in Rosedale Manor.
Scene 2 — The Gypsy Dell.
Act V. Ball Room in Rosedale Manor.

Elliot Gray . . .	Loring Underwood
Matthew Leigh . .	George E. Phelan
Col. Cavendish May . .	George L. Wilson
Miles McKenna . .	Torrance Parker
Bunberry Kobb . .	Harold A. Gale
Corporal Daw . . .	Edward C. Sherman
Romany	Thomas F. Kimball
Docksey } Robert } . . .	Robert A. Hernandez
Farmer Green . . .	Harold W. Horne
Arthur	Winthrop Brown, Jr.
Lady Florence . . .	Emily W. Underwood
Rosa Leigh . . .	Jessie Parker
Lady Adela . . .	Helen W. Ball
Tabitha Stork . . .	Elisabeth W. Adams
Primrose	Olive H. Reed
Sarah	Jenny G. Swift
Mother Mix . . .	Edna E. Peirce

Stage Manager Eugene E. Peirce
Asst. Stage Managers Harold W. Horne, Arthur Bean
Electrician Edward C. Sherman

GYPSIES

Rachael Johnson	H. Scott Dennett
Olive H. Reed	Alfred W. Elson
Nancy Swift	Ralph Hoffmann
Alice L. Winn	Harold W. Horne
Charles F. Barrett	George T. Locke
H. Robert Bygrave	J. Herbert Stedman

SOLDIERS

Benjamin Ayer	Albert C. Rogers
Paul C. Ayer	Irving Rogers
Henry Lincoln	R. J. Ross
Edward L. Lincoln	William E. Wellington
Paul C. Rockwood	Roland Wilkins
Samuel Robbins	Dana M. Wood

MUSIC

Mrs. S. K. Swift	Emily F. Hunt
Mrs. W. P. Dudley	Adaline M. Swift
Jenny G. Swift	Sarah M. Diaz
C. R. Hunt	

Shown here is the program of the Belmont Dramatic Club's second production, *Rosedale*, a romantic drama in five acts by Lester Wallack performed at the Belmont Town Hall in February 1904.

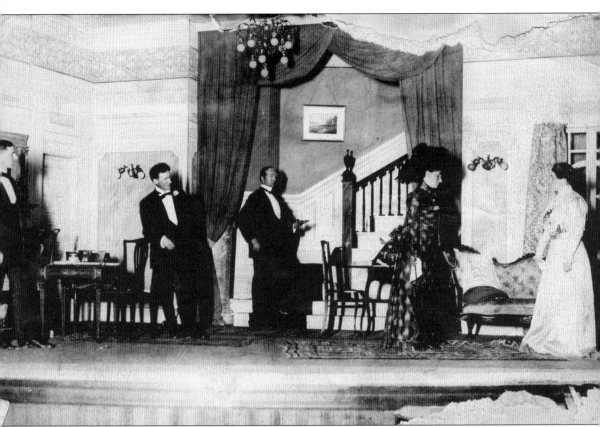

The name community theater evolved over time. The pastime has been called little theater, art theater, and amateur theater. "Community theater" was coined by a playwright with ties to the Greater Boston area, Louise Burleigh, a Radcliffe College graduate, in 1917. This photograph shows a scene from one of the Belmont Dramatic Club's earliest productions *Lady Huntworth's Experiment*, produced in 1909.

Two

ENTER THE AMERICAN PLAYWRIGHT
1920–1939

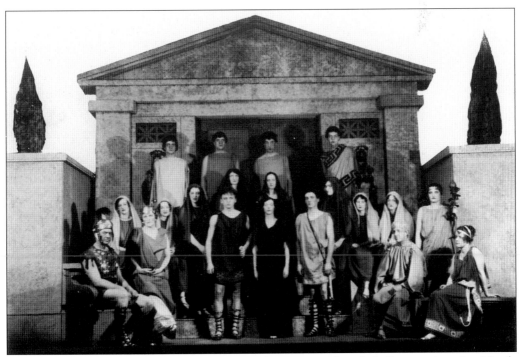

Following World War I, many more community theaters were founded all across America. Nearly 2,000 little theaters had registered with the Drama League of America by 1925, approximately 1,900 more than just 14 years earlier. Some filled the gap left by the death of the "road system," shows that came through many towns. Others provided playwrights with opportunities to craft shows. Community theaters also blossomed because of the audiences that were disappointed with the quality of commercial theater. The theaters were representative of all kinds of people, a real cross section of each community. Pictured here is the cast of *Elektra*, around 1928, performed by the Footlight Club.

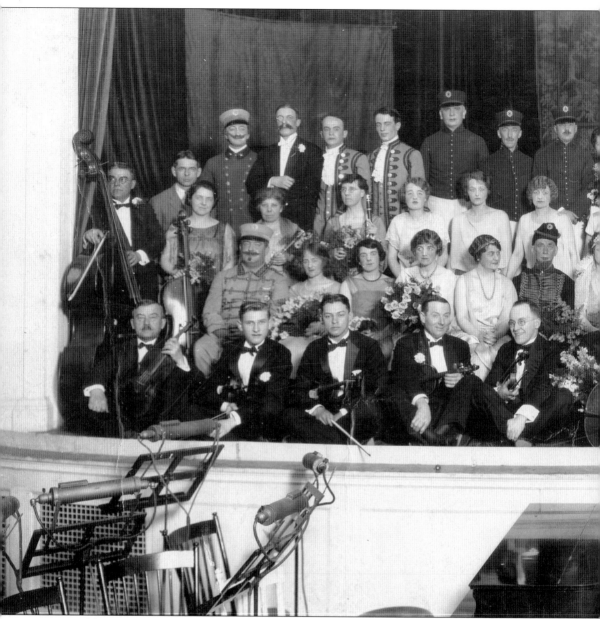

Many of the earlier theater groups were dedicated to the European art of theater, Ibsen for example, yet the decades after World War I witnessed the emergence of the American playwright and the production of American plays on the local level. Pictured here is the entire cast and orchestra of the 1925 Weston Friendly Society production of Victor Herbert's *Sweethearts*. Herbert, widely

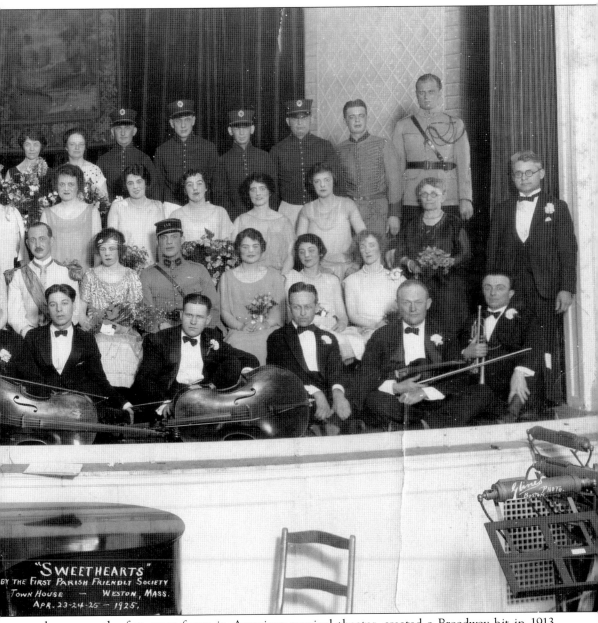

"SWEETHEARTS"
BY THE FIRST PARISH FRIENDLY SOCIETY
TOWN HOUSE — WESTON, MASS.
APR. 23-24-25 — 1925.

known as the first great figure in American musical theater, created a Broadway hit in 1913 starring Christie MacDonald (with revivals in 1929 and 1947), which led to a successful film (with a seriously altered plot) in 1938 starring Jeanette MacDonald and Nelson Eddy.

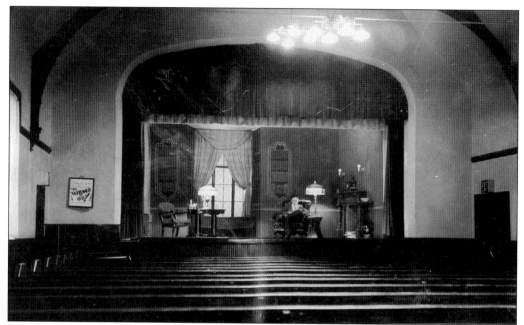

Founded in 1923 by the ladies of the Arlington Woman's Club, the Arlington Friends of the Drama (AFD) is one of the 10 oldest continually operating community theater groups in the United States. By its third public performance on April 24, 1924, men were allowed to become members and, for the first time, were cast in male roles. Shown here is the inside of the theater from the point of view of the audience. In 1947, the group removed the pews and installed a gift of used theater seats.

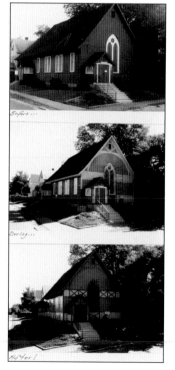

Back in the early 1930s, AFD came in with the highest bid for the St. John's Episcopal Church building, now its theater. Its winning bid was $8,200. The theater went through a major ($350,000) renovation in the summer through fall of 1997, opening with its 75th anniversary season in January 1998 in its newly renovated building. Pictured here is a series of three photographs of the outside of the AFD theater through the years.

Friends of the Drama

present at

Hambury Hall, 149 Hillside Avenue, Thursday, May 10, 1923

Their Anniversary
By Alice C. D. Riley
PERSONS IN THE PLAY

GERALD DRUMMOND, LawyerMrs. John K. Berry
FLORA, his wifeMrs. Ralph Hunt
TOM JONES, a neighbor Mrs. George A. Clark
JANE JONES, his wife Mrs. Inez Harrington
NORA, the maid Mrs. Calvin Cook
MESSENGER BOY Mrs. Oscar Schnetzer

Scene,—Porch of the Drummond House
Time,—Seven o'clock P. M.
Produced by Mrs. Paul M. White

A Minuet
By Louis Parker
PERSONS IN THE PLAY

THE MARQUISMrs. Ralph Loud
THE MARCHIONESS Mrs. Charles A. Dennett
THE GAOLER Mrs. Florence Storey
The Gaoler's living room in the prison of the Conceirge

Time,—During "The Terror"
Produced by special arrangement with Samuel French

MUSICAL NUMBER
Songs old and new

Mrs. Calvin Cook	Mrs. Ralph Hunt
Miss Ellen Percy	Mrs. Mabel Evans

Accompanist Mrs. Harold L. Frost
Arranged by Mrs. Cook

PARADE OF THE WOODEN SOLDIERS
Soldiers

Mrs. William Taintor	Mrs. Oscar Schnetzer
Mrs. Harry H. Stinson	Mrs. J. Herbert Mead
Mrs. Henry Merrill	

Accompanist Mrs. Dorothy Clements Evans
Produced by Mrs. Taintor

Shown here is the playbill of AFD's first production in 1923, *Their Anniversary*, by Alice Riley, and *A Minuet* by Louis Parker. Once exclusive, in its earliest days one became a member by invitation only, the AFD now makes a more outward effort to attract others to its theater. *The Prologue* is AFD's newsletter, and the group keeps its minutes from all of its meetings through the years in its greenroom downstairs.

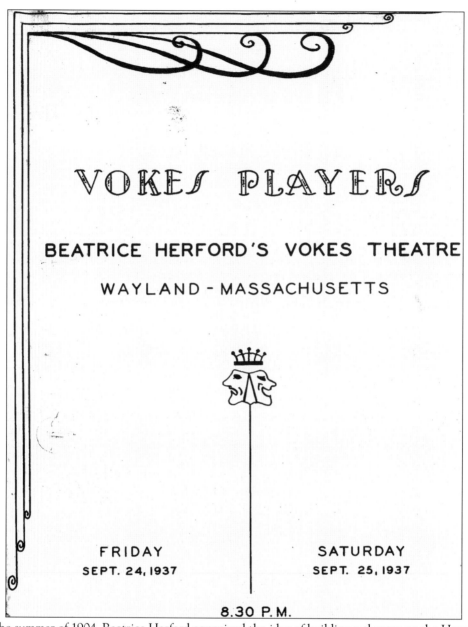

VOKES PLAYERS

BEATRICE HERFORD'S VOKES THEATRE

WAYLAND - MASSACHUSETTS

FRIDAY	SATURDAY
SEPT. 24, 1937	SEPT. 25, 1937

8.30 P.M.

In the summer of 1904, Beatrice Herford conceived the idea of building a theater on the Hayward estate in Wayland for the amusement of herself and her theatrical friends. She made a model of a theater, and Everett Small and James Linnehan built it along with Herford. Herford named the theater after Rosina Vokes, a great English comedienne whom she very much admired. She wanted a real theater and that is what she built—real balcony, real boxes, real stage with dressing rooms, and red plush rails (stuffed with excelsior from the wedding presents of Marian Bennett Robbins, a neighbor). In June 1937, a small group, organized as the Vokes Players, received the gracious and delighted permission of Herford to use her precious theater. Herford is recognized as the originator of the monologue. Shown here is the playbill from the first Vokes Players production on September 24, 1937, two one acts *Trifles* by Susan Glaspell and *The Workhouse Ward* by Lady Gregory. The curtain riser was a series of original monologues by who else . . . Beatrice Herford herself!

HISTORICAL PLAYS

Sudbury Town House

July 1, 1939

The Memorial Congregational Church presents

THE VOKES PLAYERS in
"THE CAKEBREAD MILL"

and

THE MEMORIAL PLAYERS in
"IN THE DAYS OF 1650"

The Vokes Players joined with the Memorial Players in Sudbury on July 1, 1939, to perform two historical pieces at the Sudbury Town House, *The Cakebread Mill* and *In the Days of 1650*. This celebrated the town's 300th birthday. The program makes mention of those in the cast of *In the Days of 1650* that are descendants of the early settlers of Sudbury.

"THE CAKEBREAD MILL"

Written by Mrs. J. Sidney Stone in collaboration with Miss Helen Bartell and Mrs. John Upton

Directed by Miss Helen Bartell

Cast of Characters

Thomas Cakebread	played by	Francis Pooler
Sarah, his wife	" "	Louise Kennedy
Sergeant John Grout	" "	John Todd
George Munnings	" "	Royal Whiting
Widow Hunt	" "	Edith Cooper
Rev. Edmund Brown	" "	James Ames
Karto, the Indian	" "	William Hynes
Peter Noyes	" "	Reuben Dunsford
Edmund Rice } Selectmen	" "	Gregory Cooper
Walter Haynes }	" "	Richard Lewis
Bryan Pendleton	" "	George Tenney
Philemon Whale	" "	Daniel Kennedy, Jr.
Mistress Whale	" "	Hope Hubbard
Mistress Pendleton	" "	Constance Pooler
Mistress Tamazine Rice	" "	Dorothy Stone
Widow Buffumthwyte	" "	Emma Dickey
Mill hand	" "	George Lewis
Boy	" "	Alan Morgan

Scene 1 — Cakebread Mill.
Scene 2 — Same.

(Curtain will be lowered to denote lapse of time.)

For the Vokes Players

Stage Setting — {G. SETH NICHOLS / GREGORY COOPER

Costumes — {MRS. PHILIP BURBANK / MRS. SIDNEY STONE

Stage Manager — HUGH COLEMAN, JR.

"IN THE DAYS OF 1650"

Written and directed by Mrs. Leslie H. Barrett

Cast of Characters

Peter Noyes	played by	Clifton Giles
Thomas Noyes	" "	Clyde Brennan
Elizabeth Noyes Freeman	" "	Mildred Tallant
Abigail Noyes	" "	Margaret Salmen
Walter Haynes	" "	Harvey Fairbank
Mistress Haynes	" "	Leona Johnson
John Haynes	" "	Forrest Bradshaw
Dorothy Noyes Haynes	" "	Miriam Giles
Children of John and Dorothy Haynes	" "	Amaryllis Barrett / Beverly Giles
Edmund Goodnow }	" "	Albert Goodnow
Edmund Rice	" "	Harry Rice
John Parmenter } Selectmen	" "	Maxwell Eaton
John Grout	" "	William Grout
John How	" "	Roland Eaton
Hugh Griffin	" "	Arthur Fay

Scene — In a colonial kitchen.
Time — An autumn evening in 1650.

FOR THE MEMORIAL PLAYERS

Stage Setting and Costumes by Mrs. William Tufts

Setting supervised by Leonard Goulding

CHIPS FROM THE LOG OF HISTORY

'Tis like a dream when one awakes—
This vision of the scenes of old;
'Tis like the moon when morning breaks,
'Tis like a tale round watch-fires told.
Pierpont.

The town of Sudbury was settled in 1638, and received its name in 1639. It was the nineteenth town in the Massachusetts Bay Colony, and the second situated beyond the flow of the tide. Up to 1637 there was no white man's trail through the length or breadth of this land tract.

The first settlers of Sudbury represented the noble element that came to the New England shores at that period. They were Puritans both in theory and practice. In their native land, they had enjoyed the conveniences and luxuries of their day, but they were a practical people and possessed energies equal to the emergencies of pioneer life.

Although compelled by circumstances to economize all their resources, and to make the most of time, talents, and strength to meet the demands of everyday life, yet they adhered steadfastly to their faith in God. Their Church was first in their lives. Church membership was one of the requisites before becoming a freeman. Town meetings were opened with prayer. Even the necessities of life were granted according to how one helped to maintain the ministry. In 1647, "It was ordered that the people should have timber for their year to supply their wants, for every two shillings that they paid the ministry, one tree."

Their several sections of roads formed what was called the "Highway." A large share of it is in use at the present time. By it the settlers went to the Cakebread Mill, to the little hillside meeting house, and to the John Parmenter Ordinary.

There were many things which helped to break the monotony of the settlers' busy life, such as "log-rollings," when the neighbors collected together and helped clear the land of logs and brush; "house-raisings," when many joined hands to help raise the heavy frames; "road-breaking," when, with ox teams, they cleared the snow from the paths; corn-planting in the common fields, or "huskings" when the corn was gathered, —these, with town meetings, church life, and an occasional drill of the train-band, would serve to break up the monotony and enliven the scene at the settlement.

Toiling, rejoicing, sorrowing,
Onward through life he goes;
Each morning sees some task begun,
Each evening sees it close;
Something attempted, something done,
Has earned a night's repose.
Longfellow.

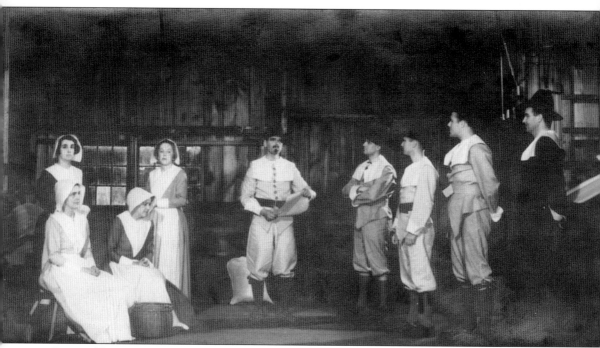

Pictured here is the cast of the Memorial Players 1939 production of *In the Days of 1650.*

The Concord Players traces its history to 1856 and the Concord Dramatic Union, which Louisa May Alcott helped to found. Alcott and her sisters would perform plays in their house and in their barn. In 1872, the union became the Concord Dramatic Club, and, ultimately, in 1919, the Concord Players. In 1921, the players added the stage with fly space, scene dock, storage facilities, and green room to the town-owned building at 51 Walden Street, then used also as an armory. Pictured here is the set of *Death Takes a Holiday*, performed in December 1937.

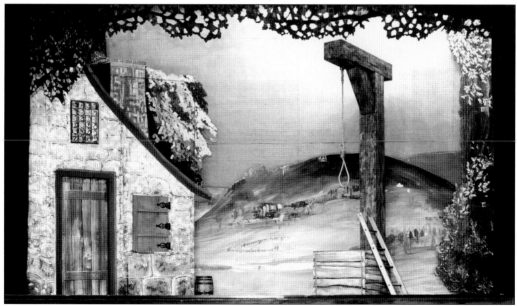

The Concord Players has been known for its wonderful sets, most recently with *Sunday in the Park with George* and *Angel Street* but also back in the 1930s as is the case with the set shown here from *Devil's Disciple*, which was performed in December 1936. (Photograph by Henry E. Towle "Flashographs.")

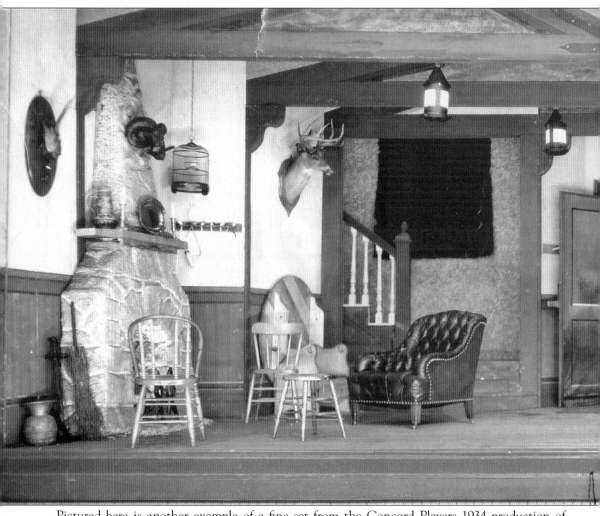

Pictured here is another example of a fine set from the Concord Players 1934 production of

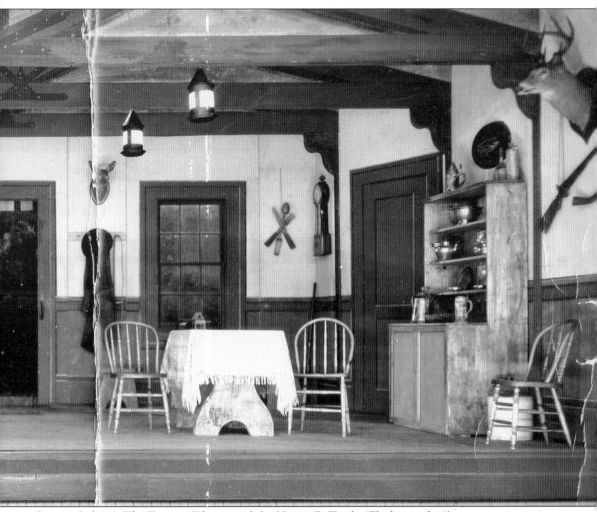

George Cohan's *The Tavern*. (Photograph by Henry E. Towle "Flashographs.")

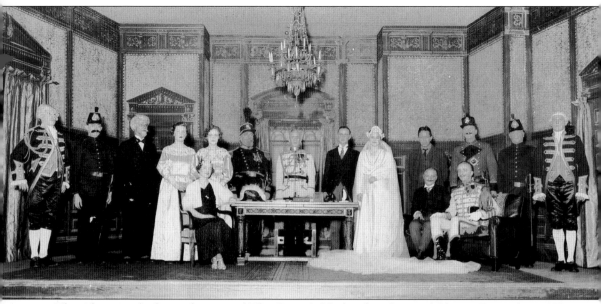

This photograph shows the cast of *The Queen's Husband*, a Concord Players December 1933 production. Standing from left to right are Kenneth Reynolds, Wilford C. Saeger, H. W. Miller, Mary Curtis, Helena A. Thompson, P. A. Davis, D. R. Grage, W. A. Tolman, Margaret Smith, W. T. Kussir, R. F. Wood, R. P. Baldwin, and F. D. Houston. Seated from left to right are Anila Abbot, George Walker, and John W. Teele.

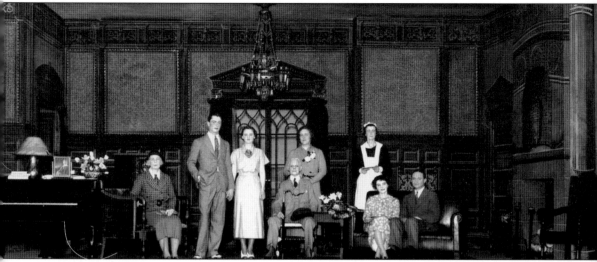

Beginning in 1915, the Concord Players negotiated with the Town of Concord to add a proscenium stage to 51 Walden Street. Both the town and individuals contributed both financial support and labor to making that stage a reality. Shown here are the fruits of that labor and another wonderfully ornate set from the 1936 production of *Mr. Pim Passes By.* Standing from left to right are David Smith, Helen Root, Gladys Brooks, and Lucy Garfield. Seated from left to right are Marguerite Edwards, Clement Edwards, Frances Warren, and George Walker.

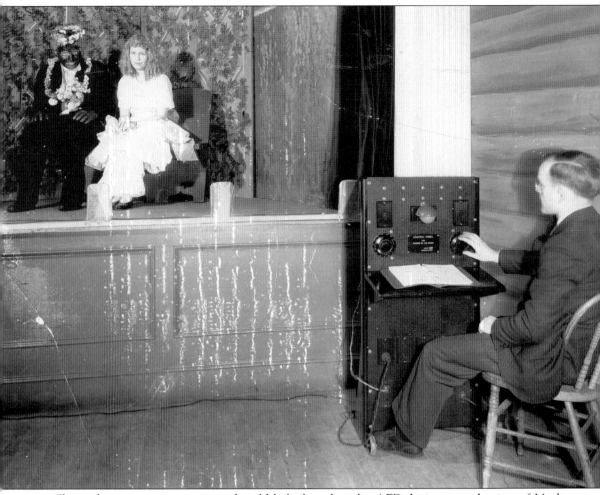

Shown here is a man operating the old light board at the AFD during a production of *Uncle Tom's Cabin* in 1933. Now everything is push button, but in the old board there were big plugs, two inches by two inches, and midway through a show a light crew person had to pull plugs out of one socket and replug them in another.

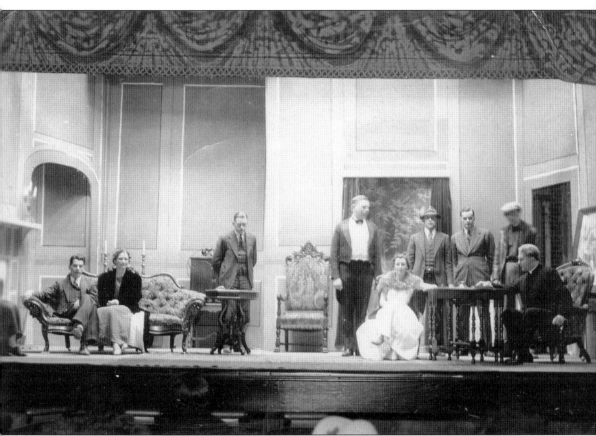

On July 18, 1937, Alfred E. MacArthur wrote a letter to Harold L. Jones of Reading. In his letter, MacArthur wrote, "You have been recommended to me as being experienced in amateur theatricals. I intend organizing an amateur group for the purpose of producing plays during the coming Fall and Winter. If I can secure enough of experienced amateur actors in Reading and vicinity, productions will take place in Reading." Approximately 14 weeks later, in a YMCA hall, a group of about 40 young men and women from Reading and Wakefield, interested in amateur dramatic production, completed the organization of the Quannapowitt Players. Pictured here is the cast of the group's first production, *The Bishop Misbehaves*, produced in February 1938 at the Princess Theater in Wakefield and restaged in March 1938 at Shepardson Hall in Reading. This is from the dress rehearsal. Standing from left to right are Harold Jones, Paul Mich, Loriston Stockwell, Martin B. Shedd, and Loring Mann. Seated are Warren Bacon, Rachel Curtis, Theresa Collins, and Philip Parker. Clyde H. Cummings was the director. Admission was 50¢.

The Quannapowitt Players enjoyed enormous success through the years continuing to the present time. Their reputation for excellence and artistic merit stands as a model for all community theater. Immediately following the group's first production of *The Bishop Misbehaves*, the *Wakefield Item* printed several articles about the group, its first production, and its novel experiment, as seen here in one of such articles, of the makeup committee giving a practical demonstration of various types of makeup.

Shown here is a scene from the Quannapowitt Players production of *The Bishop Misbehaves*. From left to right are Harold Jones, Theresa Collins, and Philip Parker. In an article about the show in the *Reading Chronicle* written on March 11, 1938, it is noted that Parker "is well known here for his dramatic work. When a student at Bowdoin he was a leader in public speaking as well as footlight activities." It was also noted that Collins, a teacher in the Wakefield schools, "gave a thoroughly enjoyable portrayal," and that Jones "is a new figure in amateur dramatics for Readingites and will be a welcome one in future productions."

This picture was taken from the wings during the Quannapowitt Players October 1938 production of *The Late Christopher Bean* performed at Wakefield High School. Shown here are Clyde Cummings, Alice Donegan (prompting), and Earl W. Campbell.

In the true spirit of community, portions of local production ticket sales are donated to other non-profit groups in town, such as various charities and in the case of early Qunnapowitt Players productions, the YMCA. Shown here is a scene from their October 1938 production of *The Late Christopher Bean*. From left to right are Helen Knight-Graves, Katherine Dow, Eleanor Nelson, Priscilla Whitcombe, and Harold L. Jones.

Three

MULTIPLYING LIKE RABBITS AND DYING OFF LIKE FRUIT FLIES
1940–1959

Former American Community Theater Association president Jeanne Adams Wray used to say that community theaters had an unnerving propensity for "multiplying like rabbits and dying off like fruit flies." Despite the growth, and demise, of local theater, there has and will always be an audience grateful to spend their money on tickets to enjoy a night out. Shown here is the audience at Wakefield High School Auditorium during a production of *Ghost Train* performed by the Quannapowitt Players in September 1942. Note the formal dress.

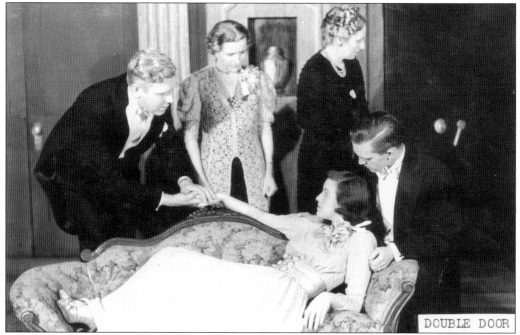

Pictured here is a scene from the Quannapowitt Players May 1940 production of *Double Door*. The show was performed at Shepardson Hall in Reading. From left to right are Paul Mich, Ruth Westcoit, Constance Roberto, Lois Newhouse, and Francis Hayward.

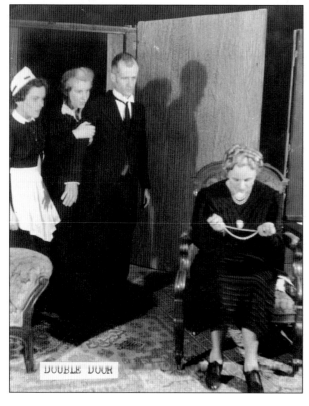

Shown here is another scene from *Double Door*. From left to right are Rita Lewis, Helen Harding, Whit Marlow, and Constance Roberts.

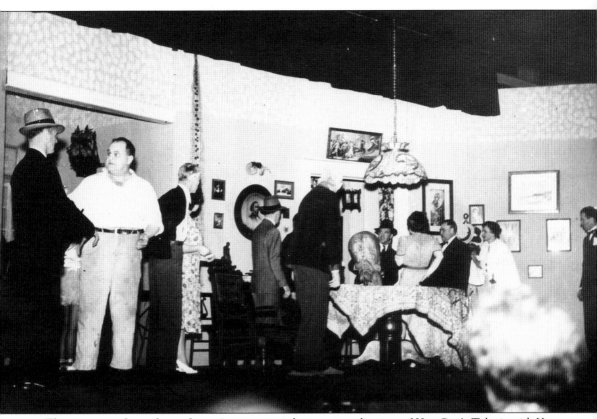

This image is from the audience's viewpoint during a production of *You Can't Take it with You* produced by the Quannapowitt Players in February 1942.

HOSPITALITY

FRIDAY

Dr. and Mrs. George Crowell Mr. and Mrs. L. Francis Kennedy

SATURDAY

Mr. and Mrs. Richard B. Rice · Mr. and Mrs. Kenneth Wright

USHERS

FRIDAY

Constance Ludcke Miriam Williams Jane Frizzell
Ann Holladay Margaret Sherman Martha Hazen

SATURDAY

Nancy Cleveland Janet Linn Marjorie Linn Hope Griswold
Judy Jennings Judy Thompson Roberta Stanton

AKCNOWLEDGEMENTS

Filene's in Belmont

Reid - Hoffman

Winter's Hardware Co.

Wyatt Typewriter Store

Belmont Police Department

Belmont High School Athletic Department

NEXT ACTIVITY

Spring Play

"EVER SINCE EVE"

A Comedy in Three Acts

by FLORENCE RYERSON and COLIN CLEMENTS

The Ninetieth Production of the Belmont Dramatic Club

Shown here is the program cover to *Ever Since Eve*, the 90th Belmont Dramatic Club production, performed in February 1947. The play was directed by Edmund M. MacCloskey. The logo is the original logo of the club.

THE BELMONT DRAMATIC CLUB

Richard B. Rice, President
Dorothy Wright, Vice-President
George M. Olive, Treasurer
Willa Wye Rockett, Secretary

DIRECTORS

1946-49	1945-48	1944-47
Elizabeth Kimball	Marion McKee	Chester L. Sandiford
Dorothy Young	Kenneth D. Tucker	Kathleen Clark Cosgrove
Carlton Laing	Charles R. Betts	Fred P. Luetters
Charles L. McHugh, Jr.	William A. Sturgis	Gwendolyn K. Nickels

PLAY COMMITTEE
Evelyn Kennedy, Chairman

Christine Morgan Dorothy Wright Dorothy Wheeler

STAGING AND PROPERTIES
Christine Morgan, Chairman

Luella McElroy Pauline Swaebe Lowell Kennedy
Marion Wilkins Barbara Jack L. Francis Kennedy

COSTUMES AND PUBLICITY
Dorothy Wheeler

PROGRAMS

Joan Wright Godsell Dorothy Wheeler

TRY-OUTS
Dorothy Wheeler, Chairman
Katherine Mulhern

Edmund MacCloskey Dorothy Wright Willa Wye Rockett

SUPPER MAKE-UP
Dorothy Wright, Chairman Richard B. Rice
Bertha C. Wye Eva Smith Kathleen Cosgrove Betty Goodwin

SOUND EFFECTS

"EVER SINCE EVE"

A Comedy in Three Acts
by Thornton Ryerson and Colin Clements

CHARACTERS
(In order of their appearance)

MRS. CLOVER .. Katherine Mulhern
JOHNNY CLOVER .. Leslie Freeman
MR. CLOVER .. Edmund M. MacCloskey
SPUD ERWIN .. George Oake
SUSAN BLAKE .. Barbara Cambell
BETSY ERWIN .. Sally Morgan
MARTHA WILLARD .. Helen C. Morrell
OFFICER SIMMONS .. John E. Morrell
HENRY QUINN .. Charles A. Godsell, Jr.
LUCYBELLE LEE .. Shirley Melvin
PRESTON HUGHES .. Karl Freeman

FOOTBALL PLAYERS
.. Lowell Kennedy
.. Bernard Higgins
.. Arthur Shaw
.. Aram Paraghamian

ACT I
An afternoon in November

ACT II
Scene One: About ten days later
Scene Two: Two weeks have passed

ACT III
Thirty minutes later

PLACE
The Clover house - in Preston, a small suburban town

TIME

Inside the *Ever Since Eve* program, Willa Wye Rockett's name is listed as secretary and prompter. A prompter is generally a member of the musical staff of many large opera houses but also can fulfill the same role in a theater; the prompter sits in a small box practically invisible to the audience, under the apron of the stage, or off stage and gives actors, singers, and choristers the lines or vocal cues seconds before they are required to say or sing them. In many international houses, where singers perform without benefit of long musical rehearsal periods, a prompter can be invaluable as a memory aide for a jet-lagged singer. Rockett started with the Belmont Dramatic Club in 1940, she has actively been involved for over 65 years.

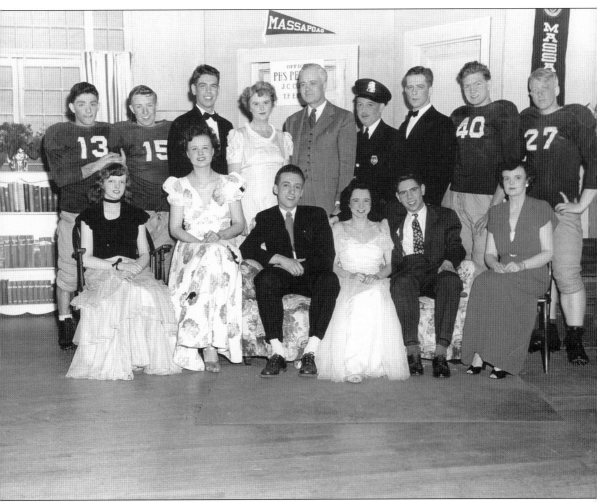

Pictured here is the cast of the Belmont Dramatic Club's *Ever Since Eve*, February 1947.

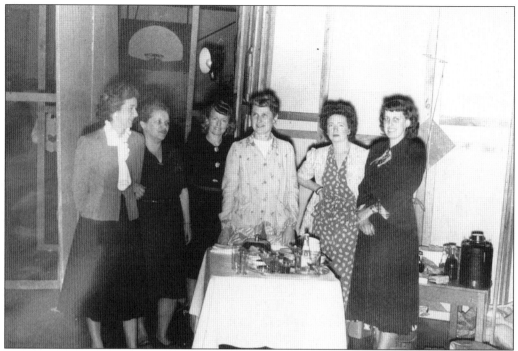

Many community theaters disbanded during wartime. Others simply made due with less shows during their seasons. The Quannapowitt Players continued and celebrated with a dance following the war. Pictured here, "the first dance since the war committee" on June 3, 1948, are Pauline Meads, Ella Stockwell, Helen Dickenson, Nina Shulkey, Irene Tenny, and Irene Webb.

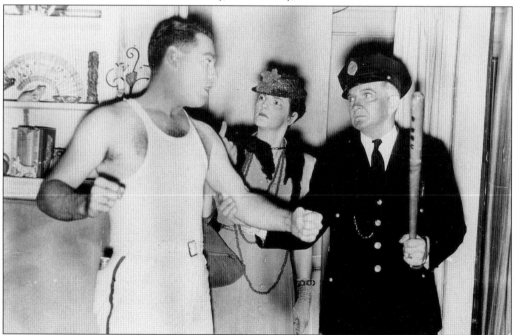

Shown here is a scene from the Quannapowitt Players November 1948 production of My *Sister Eileen*. From left to right are Charles Sturtevant and Ruth and Larry MacLeod.

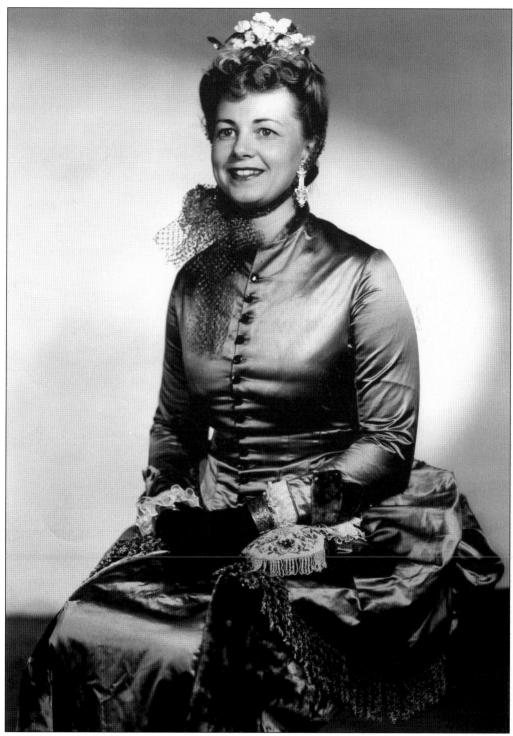

Longtime actor, president, costume designer, and makeup artist Barbara Horrigan was active with AFD for 70 years. She passed away at age 90 in 2005. She is shown here in wonderful costume for her role as Aunt Cora in the production of *Life with Father* in 1949.

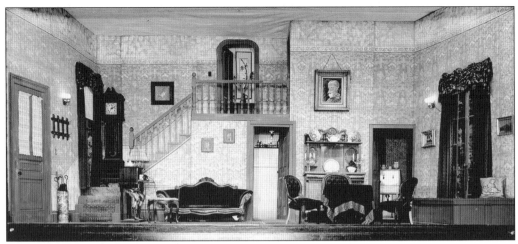

The location 51 Walden Street, where the Concord Players now make their home, is an important and historic facility with a long and distinguished history. It was built as an armory in 1887 and was used by military companies. It was damaged by fire in 1912 and repaired in 1920. In 1975, 51 Walden Street was designated as a "Permanent Bicentennial Memorial." Pictured here is the set of *Arsenic and Old Lace* in that historic facility produced by the Concord Players in 1949.

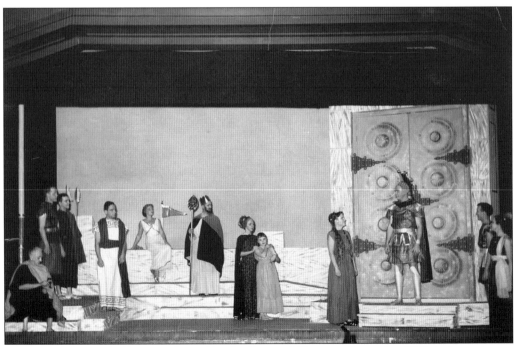

The cast of *Tiger at the Gates*, performed by the Concord Players in December 1958, is shown here.

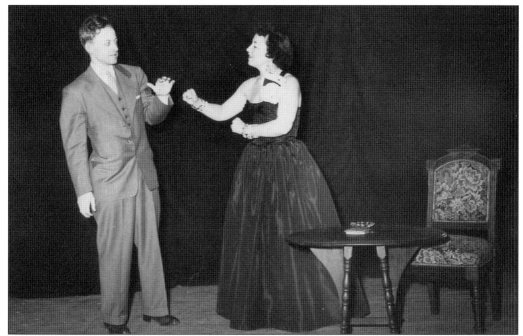

This is a scene from the Quannapowitt Players April 1950 production of *Light Up the Sky*. Pictured are W. James Lawthers and Barbara Monroe.

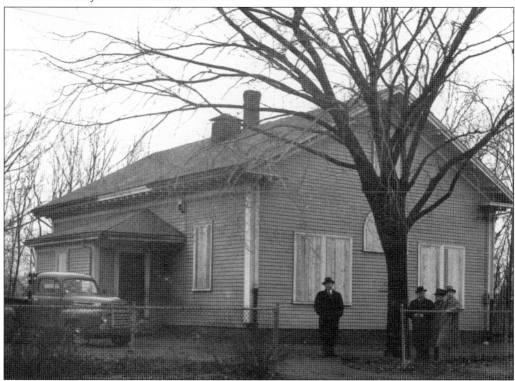

Shown here is the exterior of the Quannapowitt Players performance space at 55 Hopkins Street in Reading.

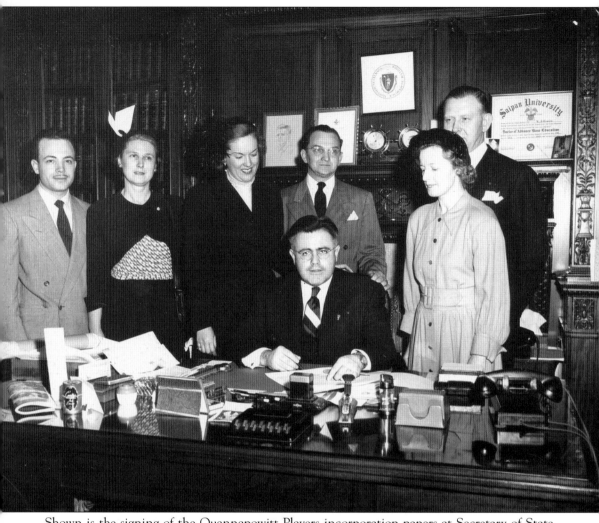

Shown is the signing of the Quannapowitt Players incorporation papers at Secretary of State Edward Cronin's office at the Massachusetts State House in 1951.

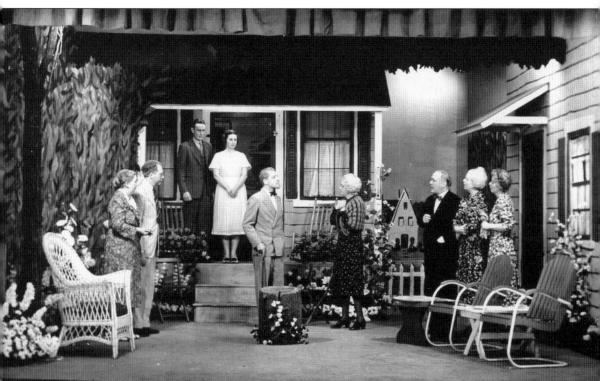

Pictured here is the cast of *Morning's at Seven* produced by the AFD in 1950. The AFD president from 1949 to 1952 was Russell T. Hamlet and the 1949–1950 season included *For Love or Money*, *The Winslow Boy*, *Knickerbocker Holiday*, *Mornings at Seven*, and *The Rivals*. During the 1983–1984 season, AFD produced *Morning's at Seven* once again. Over the course of AFD's history, the group repeated at most a dozen shows. Barbara Horrigan holds the distinction of being the only actress who appeared in an original production and the repeat. She played Myrtle Brown in the 1950 production and Esther Crampton in the 1984 production. Mary Guinan, past president, honorary member, and Myl Trempf Award recipient who was a backstage person, did the set design in 1950 and the program cover in 1984. In 1950, there were 30 technical crew people involved in the show; in 1984, there were 37.

Pictured here are Quannapowitt Players Gladys Sturtevant and James Borg from the production of *Laura* in December 1950. (Photograph by Burton F. Whitcomb, Wakefield.)

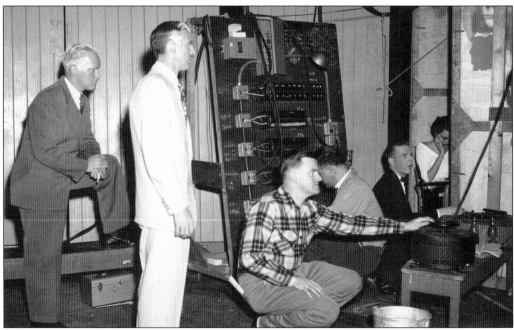

What goes on backstage is as crucial to the overall success of a play as what the audience sees on the stage. Pictured here are Robert McMaster, J. Edward Sias, Paul Black, Eldon Salter, and Gladys Sturtevant (prompting) of the Quannapowitt Players from the February 1954 production of *Ten Little Indians* by Agatha Christie. Greta Leach directed the group's 49th production.

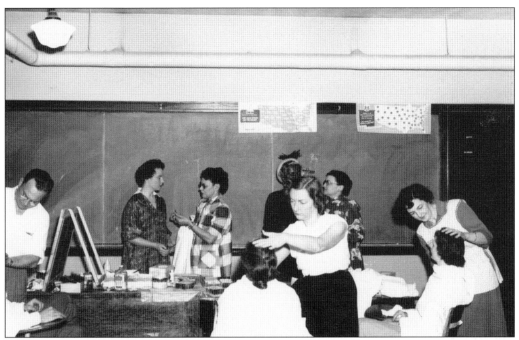

For their 46th production, the Quannapowitt Players staged *Night of January 16th* by Ayn Rand, a comedy/drama in three acts. Helen Dickinson of Reading directed, and the play was performed in February 1953 at the Wakefield High School Auditorium. Here is a picture of the makeup room with Larry MacLeod, Doris Fay, Harriet Cook, Margaret Morris, and Ruth MacLeod.

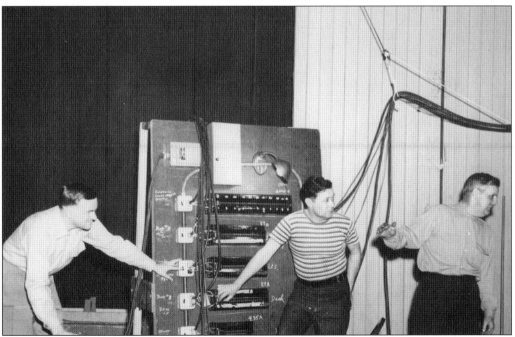

Shown here is the invaluable backstage crew for the April 1953 Quannapowitt Players production of *Angel Street*. From left to right are Paul Black, Fred Cook, and Herb Dickenson.

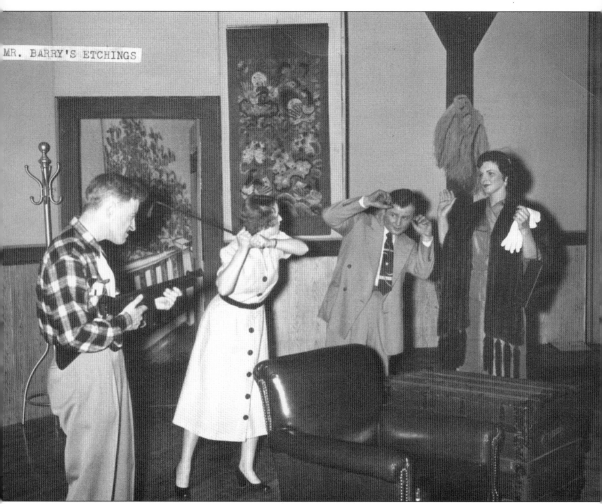

Pictured here is a scene from the Quannapowitt Players 1955 production of *Mr. Barry's Etchings*. From left to right are W. James Lawthers, Helen Dickenson, Bill Fuller, and Bernice Hubby.

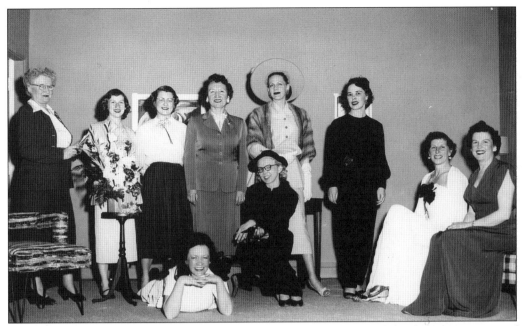

Marblehead Little Theater (MLT) was founded in 1955 by members of the drama committee of the Marblehead Woman's Club, and together they staged *The Charm Racket*. Pictured here is the cast from that production.

MLT's first full-scale production was *Light Up the Sky* by Moss Hart. While casting the show, it became evident that a much larger group was needed, so husbands, sons, daughters, and friends were enlisted. The show opened on January 18, 1956, at the Marblehead Junior High School Auditorium. Shown here is the program cover.

Marblehead Little Theatre

PRESENTS

"Light Up The Sky"

by

MOSS HART

JANUARY EIGHTEENTH, 1956

⚓

MARBLEHEAD JUNIOR HIGH SCHOOL

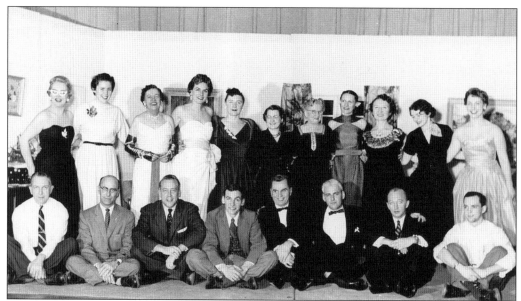

Here is a picture of the cast and production team of *Light Up the Sky* assembled onstage: Johanne Wallace as Miss Lowell, Terry Hale (manager and director), Sabra Foster Harper, Barbara Trainer, Eileen Bonnar (staff assistant), Carol Webb as Irene Livingston, Doris Ronayne as Frances Block, Lou Schneider as Stella Livingston, Donald Mackintosh as Peter Sloan, Gordon Ray as Sidney Black, Emil Schneider as Tyler Rayburn, William Rich as William H. Gallegher, Bill Brill as a plain-clothes man, Edward Fish as Carleton Fitzgerald, Earl Jenkins, Don Harper (lighting designer), Robert Hawks, and Isobel Steinmuller (makeup designer).

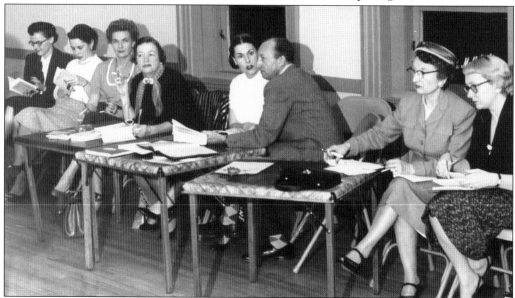

Before their first production was assembled, the casting committee for the newly established MLT undertook its most vital of duties: casting *Light Up the Sky*. Shown here is the casting committee during auditions for *Light Up the Sky*. Terry Hale is second from right. Hale, former chairwoman of the drama committee, was the first MLT president, from 1955 to 1957, and produced *Light Up the Sky*.

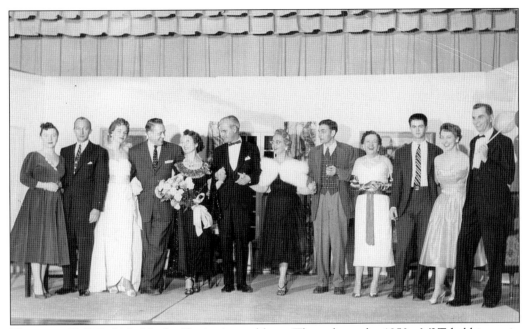

The cast of MLT's *Light Up the Sky* is pictured here. Throughout the 1950s, MLT held its main productions at the high school using the proscenium stage. As the group gained recognition, it was asked to perform at churches, charity functions, and veteran's hospitals and began including a number of one-act plays suitable for these occasions. MLT has also performed "Leonardo da Vinci" as a children's presentation at the Museum of Fine Arts in Boston. (Photograph by Don Harper.)

Shown here is a copy of the approved application for use of the auditorium at the Marblehead High School between "Little Theatre Group" and the Marblehead School Department executed on April 3, 1958. This was for use for rehearsals and performances of *Dial "M" For Murder*, which was produced June 23–June 28, 1958. Of note is the cost for general admission, $1.25, and the telephone number listed below, Neptune 8-4740.

MARBLEHEAD SCHOOL DEPARTMENT

Marblehead, Mass. **April 3,** 19.**58**.

To the Superintendent of Schools:

The undersigned makes application on behalf of **Little Theatre Group**

for the ~~use~~ of **Auditorium**

(Specify accommodations desired)

June 23 through 28, 1958

in the. **High** School, on 19...., from **7** to **11** o'clock

for the following purpose(s) **Performance and rehearsals of DIAL M FOR MURDER**

Performances June 27th & 28th – Evening estimate June 23,24,25,26

(Describe fully)

Admission rates will be **$1.25 – General Admission $1.75 reserved**

Proceeds will be devoted to **O.K.C.'S ?**

Other information

It is expressly understood and agreed that the Regulations of the School Committee are to be strictly complied with, and that the undersigned hereby assumes full responsibility for any damage to, or loss of, town property in consequence of such use of the accommodations described above, and engages to make the same good without expense to the Town. And the undersigned further agrees to pay promptly such charges as may be made for the accommodations requested.

(Name) **Marblehead Little Theatre of Little**

(Address) **2.Y. Gregory Ave Road**

(Telephone) **Neptune 8.-4740**

Application approved by. **School Committee** for **Forty Dollars each performance** rental charges.
Plus custodians' charge of $2.00 per hour with a minimum of $8.00 for each time Auditorium is used.

Date of approval **April 2,** 19**58**... Supt. of Schools.

over

51

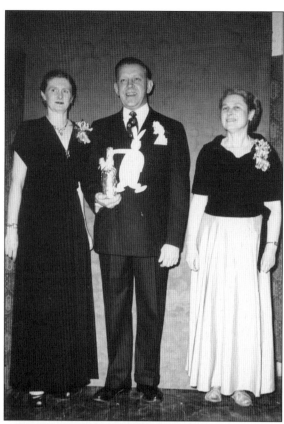

The Quannapowitt Players produced *Harvey* in February 1951. An American favorite and 1945 Pulitzer Prize winner, *Harvey* is the story about Elwood P. Dowd and his imaginary friend, Harvey, a six-and-a-half-foot rabbit. This classic comedy raises the age-old question of who is more dangerous to society: the easy-going dreamer with a vivid imagination or the people who want him to conform to the accepted version of reality. Pictured here are the directors Donna and Paul Mich with Nina Shulkey.

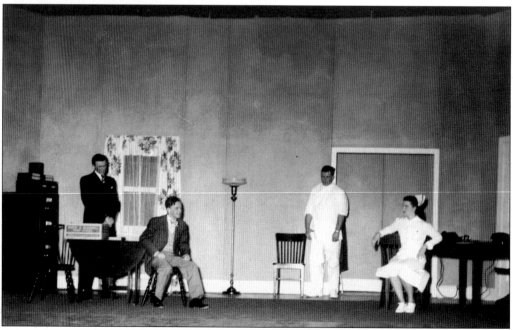

Shown here is a scene from *Harvey* produced in February 1951. From left to right are Ed Sias, W. James Lawthers, Paul Libby, and Nancy Lawson.

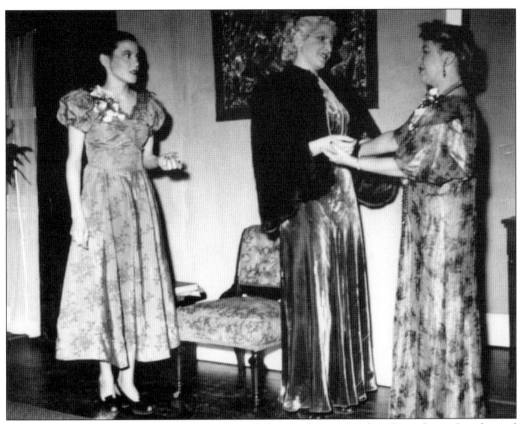

This photograph is also from *Harvey*. From left to right are Mickey Day, Greta Leach, and Barbara Monroe.

Pictured here is the set from *Harvey* at the Wakefield High School Auditorium in February 1951.

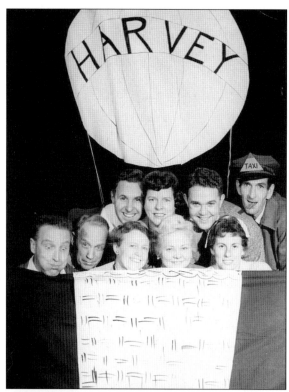

The Quannapowitt Players also produced *Harvey* in November 1959. Shown here is a picture of the cast of that production. It was restaged, directed by Donna Corbett, in 2006.

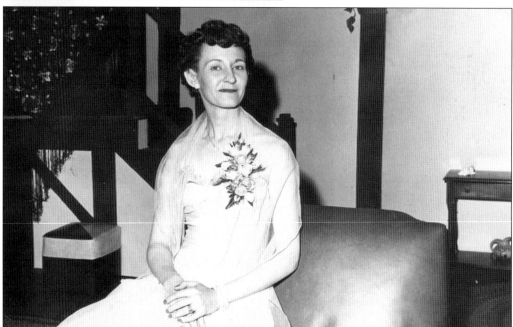

Gladys Sturtevant, an active member of the Quannapowitt Players for several years, is shown here in costume for the April 1952 production of *Guest in the House*. Sturtevant is the mother of Nancy Curran Willis, a very influential and admired director in high school, community, regional, and professional theater in the Greater Boston area for several years.

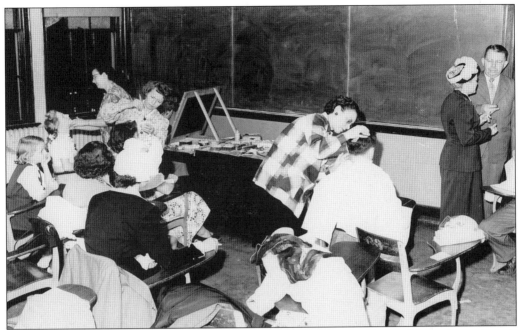

Shown here is the makeup and backstage crew from *Guest in the House*. The makeup crew is Marion Goodridge, Helen Dickenson, and Doris Fay. The backstage crew is Herb Dickenson, Bill Fuller, Fred Cook, and Jim Borg.

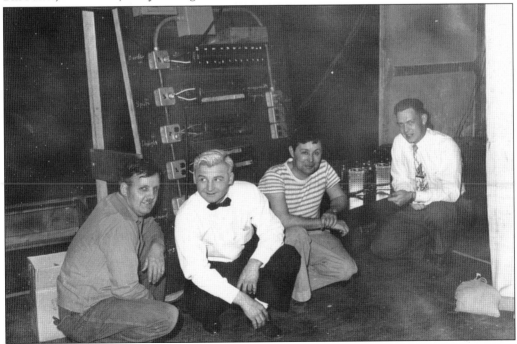

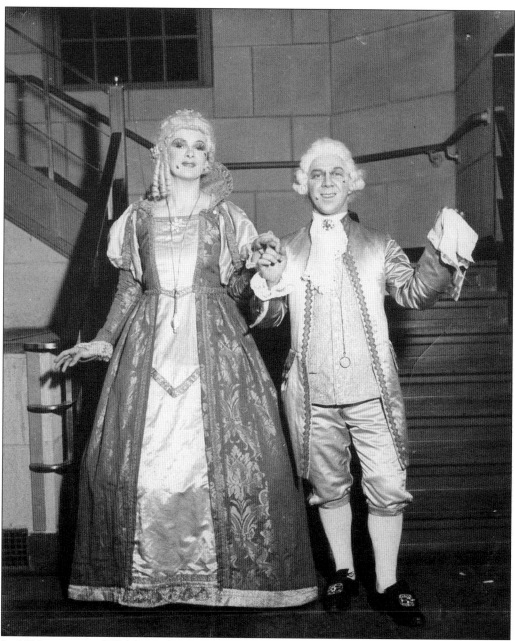

In 1936, a group of Waltham thespians calling themselves the Dramatists produced their first play, *Are You Intruding*. The Hovey Memorial Society, a men's club that existed for only a short time, invited them to use the newly constructed Hovey Memorial Building to perform their play. After the success of the Dramatists first effort, the Hovey Memorial Society invited the Dramatists to take up residence at the hall. Many productions took place at the Hovey Memorial Building between 1936 and 1952. Well used by both the players and other groups, it was the only amateur space available of this size in the area. The Hovey Players, as they are now called, have continued to produce quality community theater. Shown here are two actors from one of the group's plays around the 1940s.

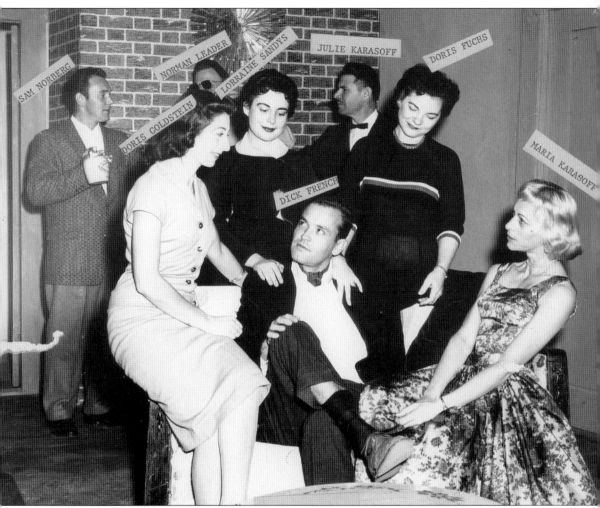

In 1952, the Hovey Memorial Society dissolved and the building was sold to the International Brotherhood of Electrical Workers (IBEW) Local 1507. The Hovey Players performed in churches, schools, the Boys and Girls Club, and in small halls throughout the area before finding its present home at 9 Spring Street in Waltham. The Hovey Players mission is to support quality theatrical entertainment and the local amateur thespian. The group celebrates the performing arts and artists throughout New England and more directly in Waltham. The Hovey players hold open auditions for all their plays. Pictured here is the cast from *The Tender Trap*, performed in November 1958. (Photograph by Ferne and Worthington, Waltham.)

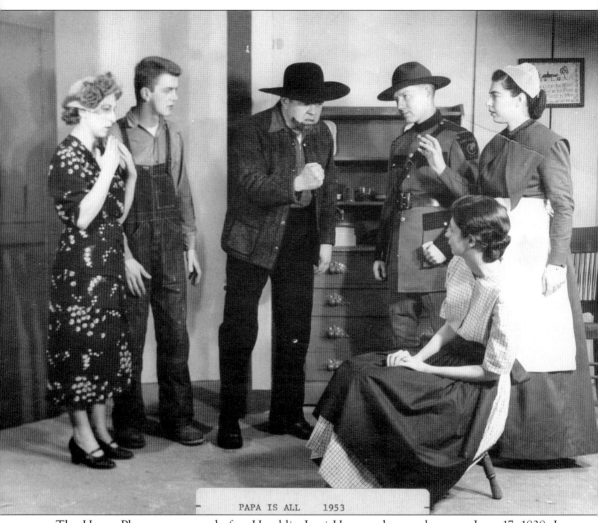

PAPA IS ALL 1953

The Hovey Players are named after Hamblin Levi Hovey, who was born on June 17, 1838. In 1861, Hovey enlisted in Company M of the first regiment of the Massachusetts Cavalry and went with the regiment to Hilton Head, South Carolina, in October 1867. When Hovey returned to Waltham, he entered the office of J. W. Parmenter, coal, wood, and brick dealer. He married Harriet Adelaide, daughter of his employer Jonas Willis Parmenter and Harriet (Kingsbury) Parmenter on June 3, 1868, in Waltham. Hovey died suddenly on May 12, 1904. In 1935, the Parmenter family commissioned several buildings and two were named in honor of Hovey. One was a 1,300-seat auditorium called the Hovey Memorial Building. The building consisted of a fully functional stage and a flat orchestra area that could accommodate 25 large round tables or 500 auditorium-style seats. The orchestra was surrounded on three sides by a balcony seating an additional 750 or more seats. The orchestra was often used for performance and as an arena for boxing events. The building was erected mainly for their use. Shown here is a scene from the January 1953 production of *Papa is All*.

Pictured here is a scene from the Belmont Dramatic Club's 96th production, *Papa is All*, performed in 1949 by Milton Dexter, Raymond Ridley, Bonnie Jean Hine, and Cecil Scheibe. Dexter was an integral member of the Belmont Dramatic Club for many years. Also interesting is that this was performed only four years before the Hovey Players production. Waltham is a neighboring town to Belmont and thus it is possible that a member of the Hovey players saw it and decided that it would make a good show for that group as well.

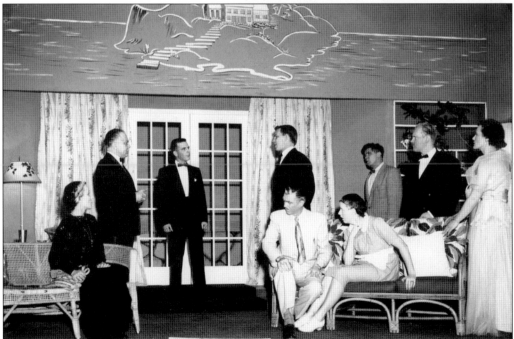

This is a scene from the March 1954 Quannapowitt Players production of *Ten Little Indians*. From left to right are Aldythe Doucette, Philip Parker, Eldon Slater, James Borg (standing), Edward Sias (seated), Mary Riley, Richard Cook, Robert McMaster, and Joanne Libbey.

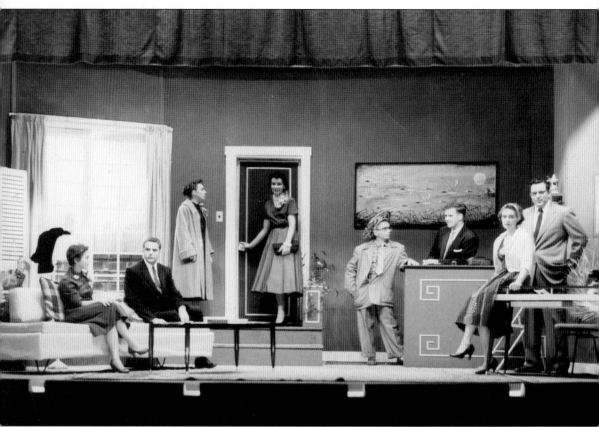

Theatre III celebrated its 50th anniversary in the 2005–2006 season. Its theater, an old historic church located on Central Street in West Acton, seats 170 people upstairs. Its downstairs is complete with a new ticket booth, a refreshment area with a large and beautiful mural on the wall, and dressing rooms. It was founded in 1955 and was known as the Little Theatre Workshop. The Little Theatre Workshop was part of three groups, together with a dance and choral group. In 1969, these three groups merged under the name Acton Community Center, Inc., doing business as Theatre III. Pictured here is a scene from the Theatre III production of *The Tender Trap* in November 1956. Doc and Barbara Johnson are far right, and Donald Oliver is in the big hat.

In the summer of 1952, Vokes Players members were saddened by the death of Beatrice Herford Hayward, and at a special ceremony a portrait photograph of her was hung in the box that had always been reserved for her use during her lifetime and which she occupied on opening nights whenever it was possible for her to be there. This was to be a permanent memorial and an expression of affection and deep appreciation. The following year her box was roped off and unoccupied on opening nights. Pictured here is a program cover from the November 1957 production of *Witness for the Prosecution* by Agatha Christie. Written within the program the audience was "requested NOT to divulge the solution of the plot to those who have not seen the play."

Beatrice Herford's Vokes Theatre

BOSTON POST ROAD

WAYLAND, MASSACHUSETTS

Twenty-Second Season Fall Production

Friday, Nov. 8, 1957 Saturday, Nov. 9, 1957

Thursday, Nov. 14, 1957

Friday, Nov. 15, 1957 Saturday, Nov. 16, 1957

8:30 P.M.

Vokes Players, Inc.

PRESENT

"WITNESS FOR THE PROSECUTION"

A PLAY IN THREE ACTS

by

Agatha Christie

Produced by special arrangement with Baker's Plays

Directed by Mercedes C. Bassett

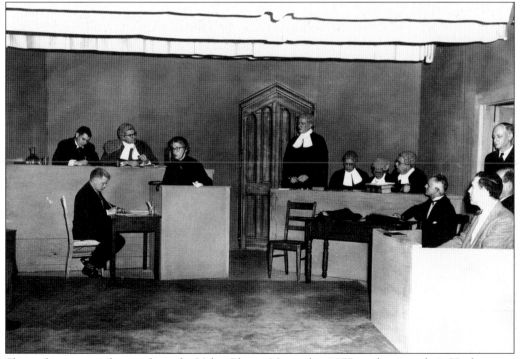

Shown here is a trial scene from the Vokes Players November 1957 production, their 22nd season, of *Witness for the Prosecution*. (Photograph by Willard B. Dik, Wayland.)

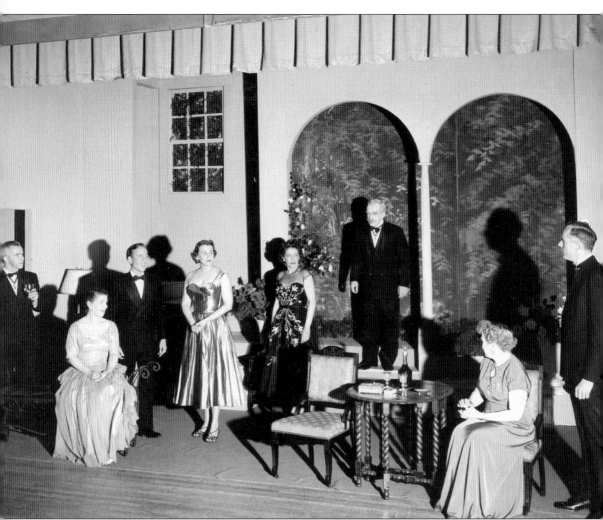

An interesting fact about community theater is that many groups often do the same shows during the same season or right after one another. An explanation is that the show might have been recently produced on Broadway and received a great deal of notoriety and suddenly the rights are available and groups like to capitalize on the publicity already generated. Another explanation is that a representative from one community theater sees another local theater's production and decides that it would work well for them too. Whatever the explanation is, *Death Takes a Holiday* is an example. Pictured here is the Belmont Dramatic Club cast from their 1956 production, performed roughly in the same few years as the Winthrop Playmakers and AFD. From left to right are Bill Hurd (Duke), Barbara Thomson (Stephanie), Harry Henneiman (Corrado), Priscilla Mead (Rhoda), Lynne Ives (Alda), Al Pywell (Baron), Willa Rockett (Primas), and Ted Sparrow (Erick).

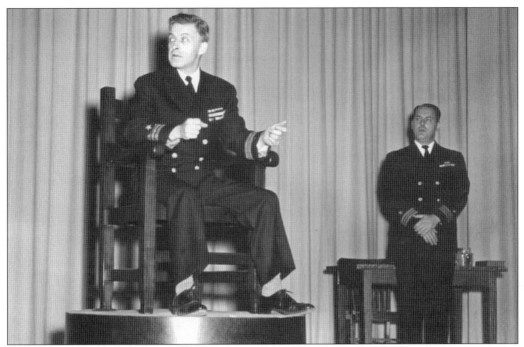

Pictured here are two actors in the court martial scene from the Quannapowitt Players October 1955 production of *The Caine Mutiny*, W. James Lawthers and Charles Sturtevant.

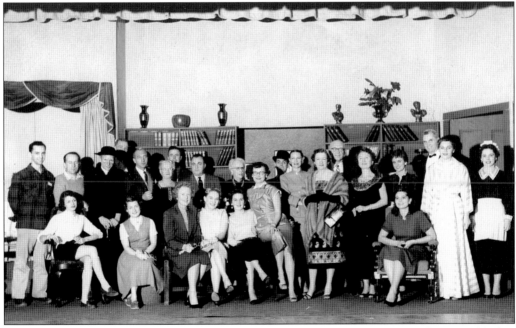

Pictured here is the cast and production staff of MLT's December 1956 production of *White Sheep of the Family*. This was the group's third production. Some of those pictured include Emil Snider, Norma Brown, Terry Hale, Lou Snider, Jo Latta, Isabel Steinmuller, Frank Callan, Nancy Jenkins, Ivan Nickerson, Jane Hagget Brown, Bob Hawks, Sabra F. Harper, Don Harper, Bill Hawks, Ned Fish, and Ed Sullivan.

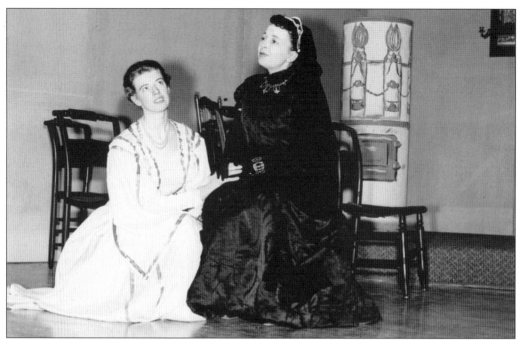

Anastasia, a Quannapowitt Players production in December 1956, starred Margaret Masters and Barbara Loveland. (Photograph by Lawrence MacLeod.)

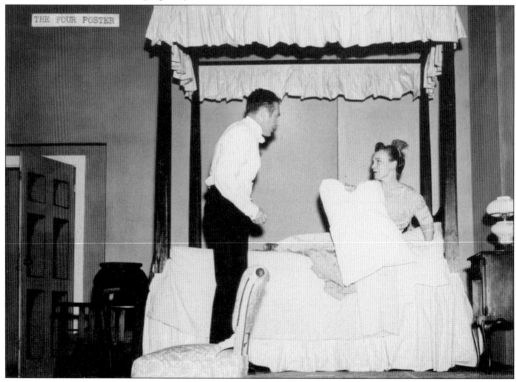

Pictured here are Gunner Blanchard and Marjorie Whittet acting in a scene from *Four Poster,* a Quannapowitt Players production in February 1957.

Pictured here are members of the April 1957 MLT production of *Mr. Angel*. From left to right are Bill Brill, Gordon Ray, Joanne Latta, and Bob Booth. This was MLT's fourth production.

Shown here is the cast of MLT's *Mr. Angel* produced in April 1957, Babs Hawkes, Delores Hillsley, Jane Haggett Brown, Joanne Lord, and Gordon Ray.

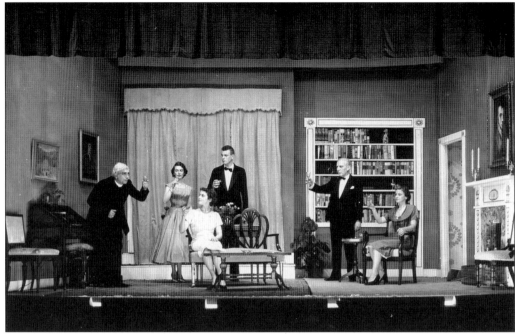

This is a scene from Theatre III's October 1957 production of *White Sheep of the Family* about a family of crooks, one of them going on the straight and narrow, starring Donald Oliver, Barbara Johnson, Jennifer Walenstein, Norman Clark, Bob Darling (the originator of Theatre III), and Pat MacLennan.

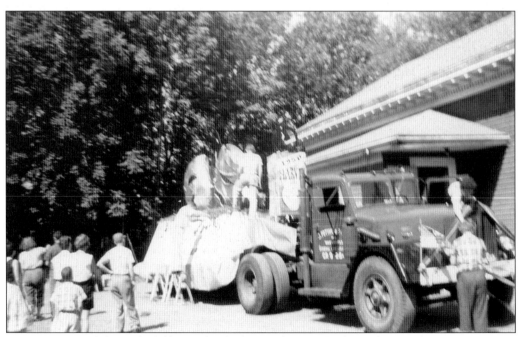

In preparation of the Wakefield Fourth of July parade in 1957, shown here is the Quannapowitt Players float in their parking lot.

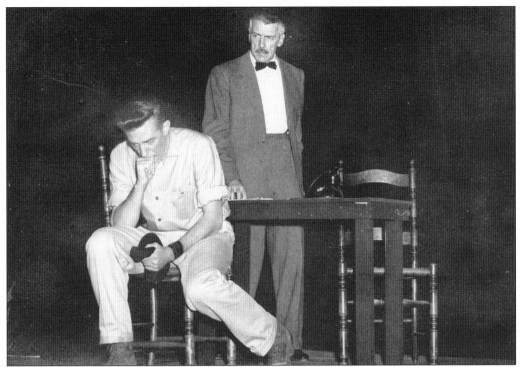

Shown here is a gripping scene from Arthur Miller's *A View from the Bridge* performed by the Belmont Dramatic Club in 1958.

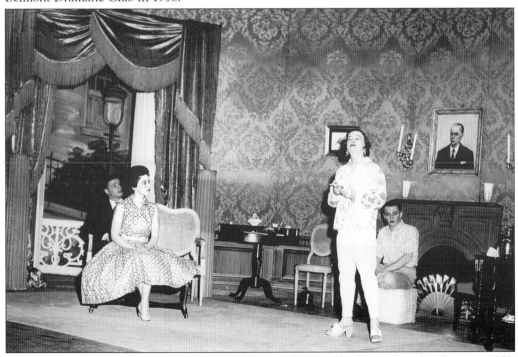

Pictured here is a scene from the MLT production of *Dear Charles* produced in January 1958. Shown here from left to right are Lou Snider, Isabel Steinmuller, and Norma Brown.

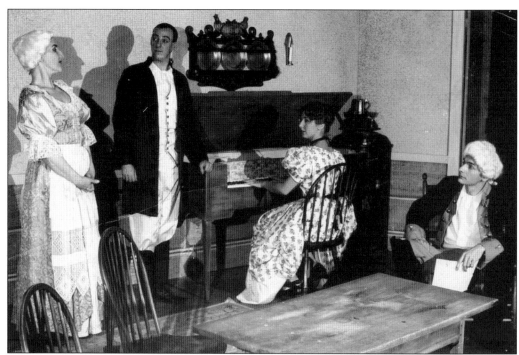

Shown here is a scene from the January 1959 MLT production of *The Pursuit of Happiness*. The show marked MLT's seventh production. Pictured are Peter Weinssenbery, Ned Fish, Joanne Wallace (at the piano), and Mary Porter.

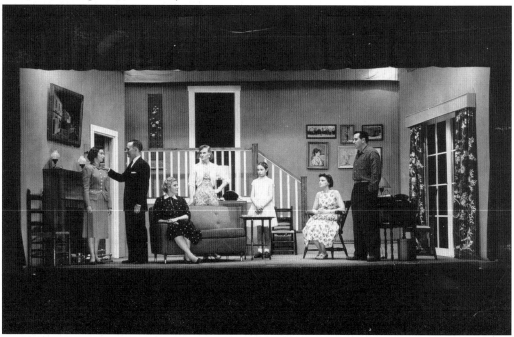

Pictured here is a scene from Theatre III's production of *Guest in the House* in March 1958. Shown from left to right are Mary Lord, Warren Costello, Doris Peterson, Jane Lewis, Joy Weinman, Pat MacLennan, and Doc Johnson.

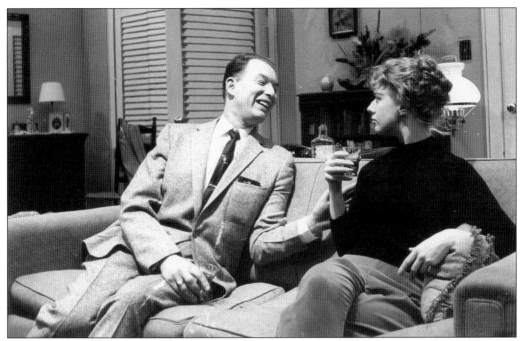

Pictured here is a scene from the February 1959 Quannapowitt Players production of *Grand Prize*. Seated are Leon Blanchard and Margaret Masters.

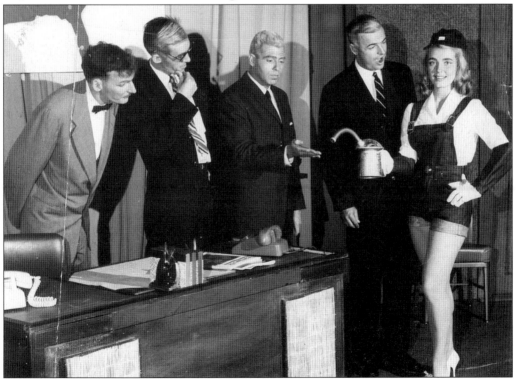

Shown here is a scene from the June 1959 MLT production of *Solid Gold Cadillac*. From left to right are Ned Fish, Miller Vera, Ed Sullivan, Bob Weiner, and Debbie Powers.

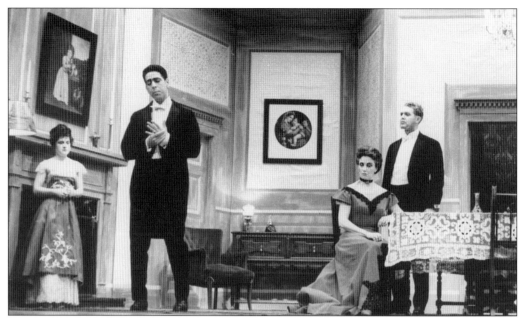

The Quannapowitt Players produced *An Inspector Calls* in April 1959. Pictured here is a scene from that production. From left to right are Nan Dreselly, David Mauriello, Barbara Cate, and Robert Hackett.

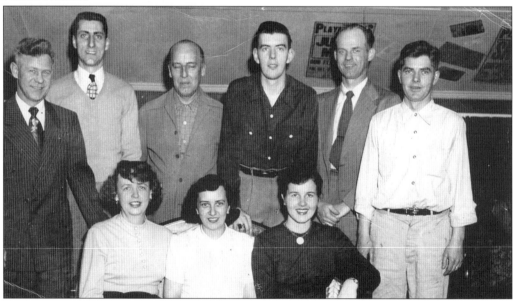

A group of the Winthrop Playmakers is at the Old Barn, behind the house next to the Methodist church at Metcalf Square. This was the rehearsal space used during the 1950s. Some of the people pictured here are Henry Democell, Alan Stanley, William O'Brien, Ross Gilchrist, and Donny O'Brien. The Winthrop Playmakers is a non-profit corporation founded in 1938 and incorporated in 1965, serving Winthrop and surrounding communities with 100 members performing four to six productions each year. Their mission statement is "to foster and promote an appreciation of the theatre arts and to stimulate production of living theatre for the entertainment and cultural enrichment of the community."

William Story, longtime treasurer of the Winthrop Playmakers, was a member of the organization from as early as their second production through the 1950s. A popular saying from another longtime member, Margaret (Peg) Smith, was "It's easier to get to be a star in Winthrop than it is out in the big wide world."

Russ Gilchrist, one of the founders of the Winthrop Playmakers, is pictured here around the 1950s.

Shown here is a scene from the November 1959 Quannapowitt Players production of *Harvey*. From left to right are Mary Riley, Jodie Cooney, W. James Lawthers, and Helen Dickenson.

Four

INTERMISSION, TIMES ARE CHANGING
1960–1979

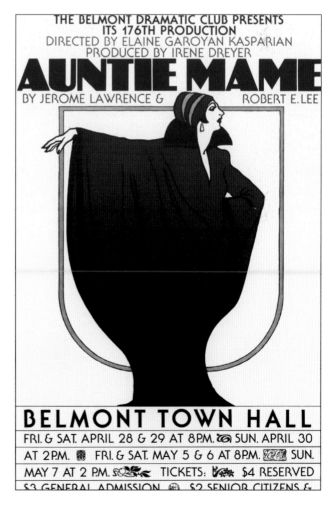

THE BELMONT DRAMATIC CLUB PRESENTS
ITS 176TH PRODUCTION
DIRECTED BY ELAINE GAROYAN KASPARIAN
PRODUCED BY IRENE DREYER

AUNTIE MAME

BY JEROME LAWRENCE & ROBERT E. LEE

BELMONT TOWN HALL

FRI. & SAT. APRIL 28 & 29 AT 8 P.M. SUN. APRIL 30
AT 2 P.M. FRI. & SAT. MAY 5 & 6 AT 8 P.M. SUN.
MAY 7 AT 2 P.M. TICKETS: $4 RESERVED
$3 GENERAL ADMISSION $2 SENIOR CITIZENS &

Shown here is an example of one of the many fine artistic renderings for community theater posters. This is from the Belmont Dramatic Club's 176th production, *Auntie Mame*. As many community theaters continued with what had worked for them in the past, many others had to change with the times; men and women were now working outside the home, commuting was longer for many people, and television was becoming primary, and less costly, entertainment. Many community theaters had to shake things up, do some more edgy pieces, and take more risks to attract volunteers and audiences.

Decisions must be made. Here is a photograph of the casting committee during auditions for the Quannapowitt Players February 1960 production of *Ah Wilderness*.

This photograph shows the cast of MLT's June 1960 production of *Bell, Book and Candle* viewing the set design. Shown here are Bobbi Smith, Lee Smith, Don Harper, Sabra Foster Harper, and Isabel Steinmuller. Right from the start one thing that has distinguished MLT from other community theater has been its expertise in technical matters. The group has had the good fortune to have people highly knowledgeable in the art of stage lighting and set design, among them Don and Sabra Harper.

Pictured here is a scene from MLT's 13th production *Bell, Book and Candle*. From left to right are Ed Snow, Palmer Worthan, Bob Haight, and Jo Latta.

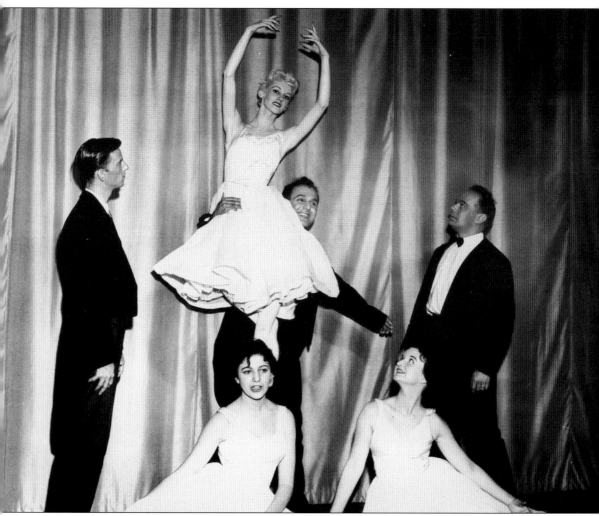

Shown here is a scene from the Belmont Dramatic Club's 1961 production of *Nothing but a Dream*. This was an original play produced for the first time.

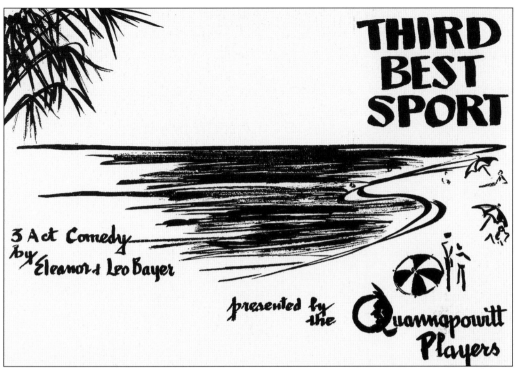

This is the cover of the program for *Third Best Sport*. This production was performed at Wakefield Memorial High School on April 21 and 22, 1961. This marked the Quannapowitt Players 74th production.

STAFF FOR THIS PRODUCTION
at
WAKEFIELD MEMORIAL HIGH SCHOOL
APRIL 21 AND 22, 1961
our seventy-fourth production

SET DESIGN: John Deering

SET CONSTRUCTION: John Deering, John Neiss, Bernie Riley, Dave Valpey, Grennie Stockwell, Sterling Chapman, Charles Bickford, Walter Webb, Sumner Blanchard.

PROPERTIES: Mary Riley, Sally Jones, Barbara Smallidge, Nan Dresselly, Gloria Short, Stanley Short, Bernie Riley.

COSTUMES: Jan Bell, Rita Copp, Bea Bacon, Helen Lawthers, Rita Valentine.

MAKEUP: Ralph Smallidge, Charlotte Cook, Grennie Stockwell. Helen Dickinson, Greta Leach, Nina Shulkey, Larry MacLeod, Julia Leo.

USHERS: Marge Whittet and Barbara Blanchard with Junior Quannapowitts:
Bill Bell, Jr., Sandra Berry, Jerry Copp, Judy Copp, Sharon Madden, Harold Macaughey, Bruce MacKenzie, Peter Sjostrom, Sally Thomas, Judy Valpey, Barbara Youtz.

PHOTOGRAPHY: Harry Holbrook

PUBLICITY: Marge Whittet, Nancy Goddard, John Deering, Margaret Masters, Dave Valpey, Harry Holbrook, Bea Bacon, Mary Valpey, Terry Rodda, David Mauriello.

LIGHTING: Bill Fuller, Bob Hassinger, Dave Dresselly

PROGRAM DESIGN: Barbara Blanchard

HOUSE MANAGEMENT: Mac Whittet, Paul Mich, Bill Bell.

BUSINESS MANAGEMENT: W. James Lawthers

PRODUCTION CO-ORDINATOR: David Mauriello

TICKETS: Ella M. Stockwell, Nina Shulkey, Donna Mich, Louise Gowing, Jodie Cooney, Peg Avjian.

"THIRD BEST SPORT"
By Eleanor and Leo Bayer

Directed by Margaret Masters
Assisted by Frances Marelli

CAST OF CHARACTERS

BELLBOY	*Emmons Bowles*
HELEN SAYRE	*Carol Webb*
DOUGLAS SAYRE	*Bryce Blanchard*
CHUCK ROBBINS	*Terry Rodda*
ARTHUR UNDERHILL	*Bill O'Donnell*
AMY UNDERHILL	*Mary Valpey*
MARGE ROBBINS	*Nancy White*
JOHN WAGNER	*J. Edward Sias*
DR. JONAS LOCKWOOD	*David Mauriello*
MYRA McHENRY	*Evelyn Holmes*
SPENCER McHENRY	*Milton Copp*

The action takes place in the living room of a hotel suite in Palm Beach, Florida.

ACT I

SCENE 1: 11:00 a.m. A day in March.
SCENE 2: Later that afternoon.

ACT II

SCENE 1: Next morning.
SCENE 2: That evening.

ACT III

Later that evening.

This production by special arrangement with Dramatist Play Service Inc.

OFFICERS FOR THE 1960 - 1961 SEASON

President, F. Bryce Blanchard *Secretary,* Margaret Masters
Vice-President, David Mauriello *Treasurer,* Ralph Smallidge

DIRECTORS

Willam Bell Harry Holbrook
W. James Lawthers Mary Valpey
 Marjorie Whittet

We hope you have enjoyed our 24th season of Plays. Be back with us in the Fall when we open our 25th year with our 75th production.

And note too that our 25th Birthday will occur during the 1962 - 1963 season. So stay with us. We'll be doing lots of celebrating during the next two years.

Keep us in mind as you plan your program for next year. We'll be glad to help you with make-up or lighting, or to entertain your membership with a one-act play. Our charges are reasonable.

May we again invite you to active membership. Come back stage tonight and get acquainted. Visit our Annual Meeting on Friday, May 5. You will be most welcome.

Our thanks to DeVita's Flower Gardens, Vernon St., Wakefield for the table bouquet used in tonight's performance; and a salute to American Mutual for the loan of furniture for this production.

Shown here is the inside of the program of *Third Best Sport*.

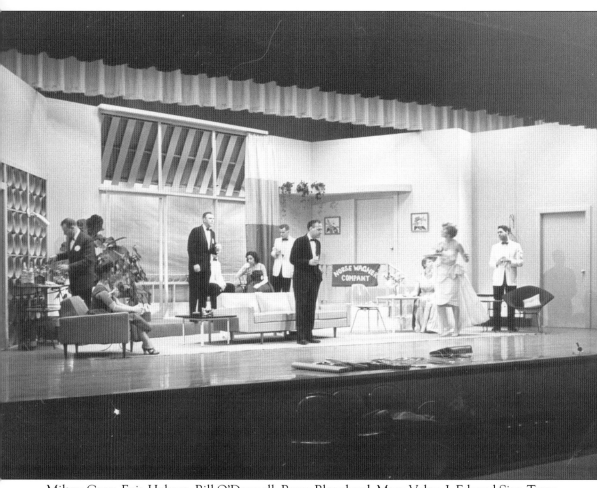

Milton Copp, Evie Holmes, Bill O'Donnell, Bryce Blanchard, Mary Valpy, J. Edward Sias, Terry Rodda, Nancy White, Carol Webb, and David Maurirello are shown during a rehearsal of the Quannapowitt Players April 1961 production of *Third Best Sport*.

TO: The MLT Executive Board

FROM: Sabrah Harper, Stage Manager, The Crucible

SUBJECT: Gasting for The Crucible

As Stage Manager I attended the cwo casting sessions for The Crucible, and would like to formally issue my displeasure with the running of the casting committee. As Stage Manager I also received complaints from members who were trying out for parts.

Firstly, I was very upset with the complete lack of attention the committee paid to the MLT policy that new, untried people must not be cast in major parts. This policy was explained to all members of the casting committee but was disregarded. This policy is also generally known to the membership at large. On this same point I feel the two minor rolls which were given to non-members could have been played by old, tried and true members of MLT who tried out with equal competence.

Secondly, I shall register the complaints made to me by members who were trying out for parts in this play. The feeling was that they were:

#1. not given enough time to read.
#2. not given parts to read which they had signed up to try out for.
#3. not given parts in the play to read which would show off the character to best advantage.
#4. treated rudely when they asked to read a specific part.

I would also like to comment on the time it took the committee to cast this 21 character play. From my own experience on casting committees it seems to me that it should have taken a bit more than an hour and a half to deliberate the handing out of parts to such a large cast.

Lastly, I would like to question wether the committee acted as a committee or whether the director cast the play with little respect for the comments, opinions, and reccommendations of the other members of the committee.

April 24, 1962

Casting is a very tricky business for community theaters and may cause distress for those involved on both sides of the process. But if done correctly, a good cast can make a production succeed on a variety of levels. Shown here is an April 24, 1962, letter to the MLT executive board from Sabrah Harper, stage manager of *The Crucible*, regarding her displeasure with the casting of the show. Listed are concerns that are common at community theater auditions throughout the years. Proceeds from *The Crucible* were donated to the United Fund.

The Quannapowitt Players also performed *The Crucible* in 1962. Here is a picture from one of the rehearsals. From left to right are Loriston Stockwell, Nancy Magown, and Evelyn Holmes. The play performed at the Parker Junior High School in Reading in April 1962.

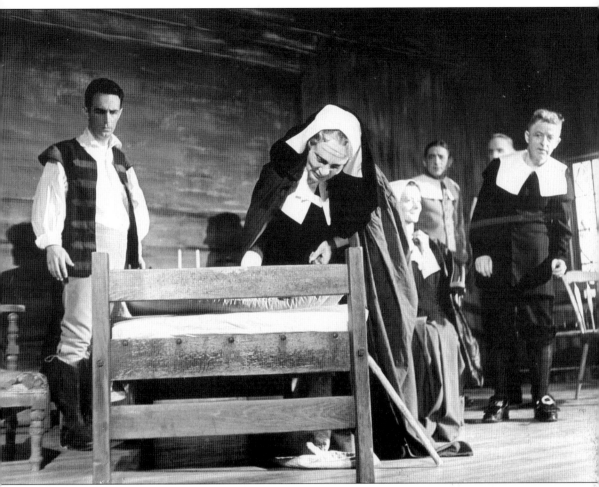

Pictured here is a scene from *The Crucible* produced by the Quannapowitt Players in April 1962, starring Harold Bond, Marge Whittet, Charlotte Cook, Mac Whittet, Sumner Blanchard, and W. James Lawthers.

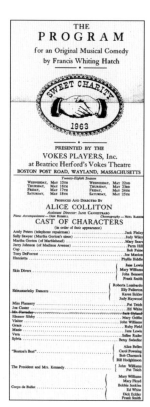

Here is an unusual example of a program in that it is vertical and lean, not a booklet like most other community theater programs. This is the program from the May 1963 Vokes Players production of *Sweet Charity*.

Shown here is the inside of the program for *Sweet Charity*.

THE MUSIC
"Here We Go Again"

ACT I — SCENE ONE
The home of Martha Gorton and her niece, Sally Sawyer, in Marblehead.
Time: the present.
"Bronze Memorial Plaque"..............................Martha Gorton
"Old North Shore".............Martha Gorton, Sally Sawyer, Jerry Johnson

ACT I — SCENE TWO
The harbor at Marblehead.
"Hanging Around the Harbor
 in the Summertime"....................Sally Sawyer and Andy Peters
"Skinamarinky Dive"................Henrietta, Sally, chorus and dancers

ACT I — SCENE THREE
Offices of Farraday and Rice.
"Deep Down Me".......................................Eleanor Silsby
"Coffee Break"....................Eleanor Silsby, chorus and dancers

— INTERMISSION —
"Sweet Charity"

ACT II — SCENE ONE
Offices of Farraday and Rice (six months later).
"Nembutal".............................Sally Sawyer and Joe Custer

ACT II — SCENE TWO
Office on Route 128 of "Electronics, Unlimited".
"Sign of Spring".....................................Vera and chorus
"Love Brings a Touch of Sadness"........................Vera and Andy

ACT II — SCENE THREE
The Boston Arts Festival.
"Dear Old Radcliffe Moon"..................Francis Whiting Hatch
"Touch and Go"..Sally and Andy
"Art, Art"..................Chorus, dancers and "Boston's Best"
"Summer Opera in the Park".............................Eleanor Silsby
Finale...The Entire Cast

Piano arrangements by George Wright Briggs

Rehearsal Accompanist — Alice Belles

FOR THIS PLAY
PRODUCTION MANAGERS — Walter Dermon assisted by Earl B. Bourne, Albert Strow, Kendall Newbert, Wesley Teich, James Richardson, Arthur Grannis and Philip Bassett.
SET DECORATION AND DESIGN — Walter Dermon, Horace Gray, Marge Purrer, Robert Briggs, Millie Eckler and Lois Cotton.
ELECTRICAL AND SOUND EFFECTS — Francis Stites, Homer MacDonald, Whitman Hall, James Richardson and Alexander Jenkins.
STAGE MANAGERS — Earl B. Bourne, Kendall Newbert and Albert Strow.
PROMPTERS — Harriet Krant and Barbara Jones . . . MAKE-UP — Carol Stites assisted by Penny Kreidl, Joan Havener and Mary Williams . . . STAGE AND HAND PROPERTIES — Dorothy Grannis, Dode Damon, Bernice White and Betty Kennedy . . . PUBLICITY — Bobby Robinson and Beatson Wallace.
TICKETS — Ann-Marie Bourne, Betty Parker, Dorothy Grannis and Weston Studio.
BUSINESS MANAGER — Robert Koch . . . PHOTOGRAPHY — Willard Dik.
WARDROBE — Cay Bourne, Sara Clawson, Martha Charnock, Fran Hill, Jane Hodgkinson, Carolyn Jones, Jane Koch, Betty Newbert, Jinni Ober and Marion Stillman.
PLAY COMMITTEE — Barbara Barrett, Chairman; Jack Hyland, Kay Weeks, John Williams, Ken Jones.
THANKS TO — Weston Pharmacy for Make-up and Arrowhead Gardens for the Ushers' Boutonnieres . . . Wig by Kenneth.

VOKES PLAYERS OFFICERS
President—Parmelee C. Hill; *Vice President*—Howard C. Weeks; *Secretary*—Suzanne Reade; *Treasurer*—Richard C. Eckler
BOARD OF MANAGERS
The Officers above and Robert H. Charnock, Walter A. Dermon, Jr., and Doris Crowell.
COMMITTEE CHAIRMEN
Building—Kendall Newbert; Community Relations—Eleanor Baldwin; Grounds—Ed White; Historians—Catherine and Willard Dik; Librarian—Beth Best; Make-up—Buff Paine; Membership—Bill Hodgkinson; Photos—Mary Floyd; Production—Earl B. Bourne; Publicity—Peggy and Rudy Bruce; Stewards—Jim Plate; Tickets—Ann-Marie Strow; Wardrobe—Ellen Bennett.

Refreshments are available at
DRIBLEY NIBBS AND COMPANY

Shown here is a cast photograph from the May 1963 Vokes Players production of *Sweet Charity*.

Shown here is a program from Vokes Players 29th season. Three one act plays were presented in March 1964.

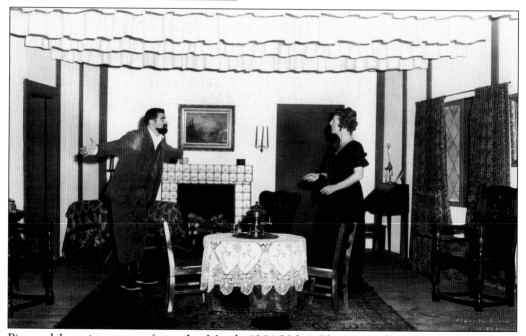

Pictured here is a scene from the March 1964 Vokes Players production of *The Boor* by Anton Chekhov. Pictured are Chris Crowell playing Grigori Stepanovitch Smirnov and Joan Moorhead playing Mrs. Popov. This was the 75th production for the Vokes Players. (Photograph by Willard Dik.)

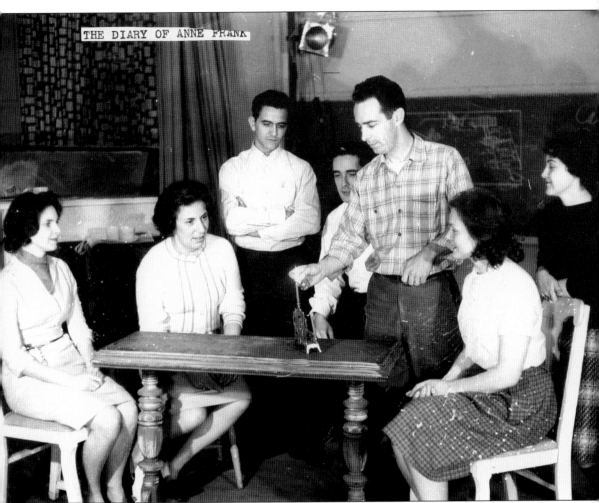

Shown here is a rehearsal of a scene from *The Diary of Anne Frank* performed by the Quannapowitt Players in 1964. From left to right are Grace Fuller, Viat Rolfsen, Bob Banda, Alden Atwood, Harold Bond, Margaret Ober, and Nan Dreselly.

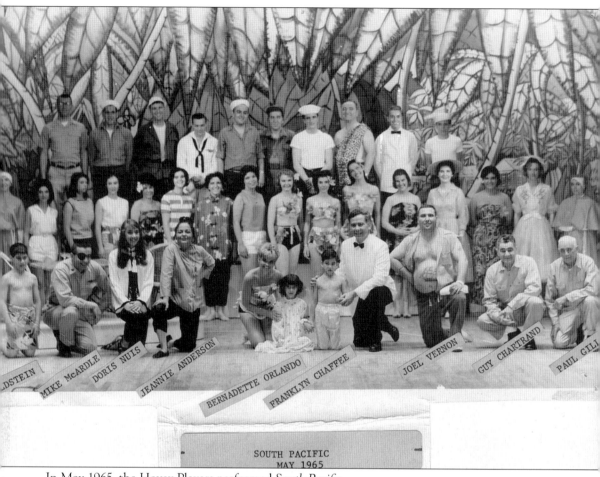

In May 1965, the Hovey Players performed *South Pacific*.

During the 1960s, MLT began awarding an annual scholarship to a member of the Marblehead High School graduating class who participated in theatrical productions during high school as well as contributed in some way to MLT. From left to right are Erold B. Beach, principal; Michael N. Armento, MLT president; Charles N. Timbie, recipient; and Nancy Faye Samas, director of speech activity.

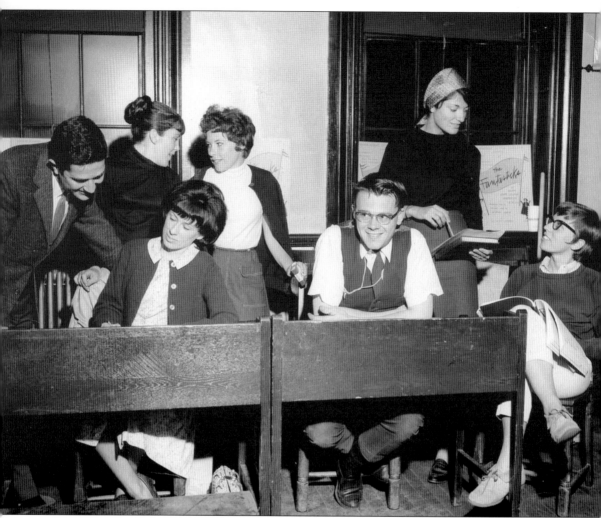

For MLT a big leap was made in the mid-1960s by the decision to take the plunge and do a musical. They got their feet wet by presenting *The Fantasticks* in June 1965 with a cast of seven, minimal scenery, and an orchestra consisting of a pianist, a harpist, and a percussionist. The show received an enthusiastic reception. Shown here is the cast. Standing in back from left to right are Ed Snow, Sue Auslanian, Sandra Gentile, and Joyce Greatorex. In front from left to right are Jill Mason, Tim Smith, and Sally Burke. In January 1970, MLT produced *The Fantasticks* for a second time.

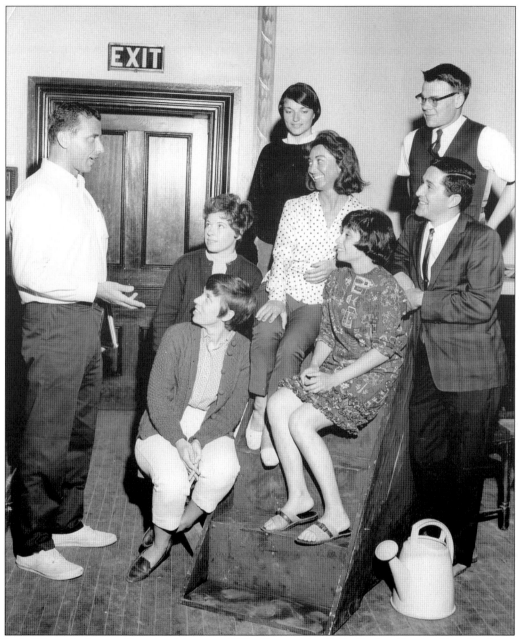

Jack Winer is shown directing his cast of *The Fantasticks*: Sally Burke, Sandra Gentile, Joyce Greatorex, Jan Staples, Esther Shaktman, Ed Snow, and Tim Smith.

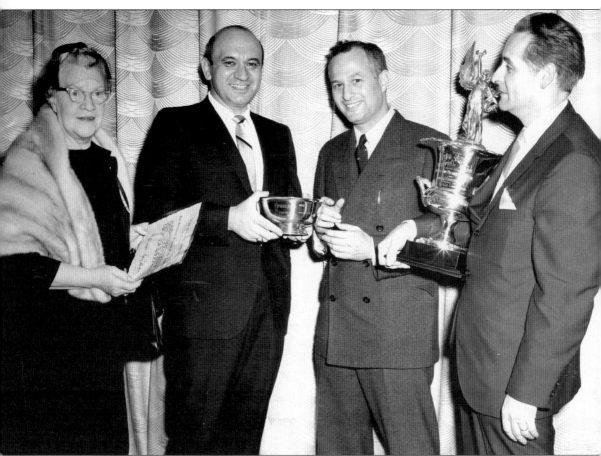

Shown here is Myl Trempf receiving the distinguished Moss Hart Award from representatives of the New England Theater Conference (NETC) in October 1967 for the 1967 AFD production of *The Crucible*. Trempf was vice president of AFD in this photograph. She later went on to become president of the AFD from 1968 to 1970 and from 1973 to 1974. She was at NETC to accept regional citation from NETC for AFD's 200th production over 44 consecutive years. The gentleman at the far right of the photograph is AFD president Richard Erikson, who was receiving the rotating award trophy. The other people in the photograph are Prof. Eugene Blackman (at left next to Trempf) of Northeastern University, who was president of the NETC, and David Hayes, who was cited by NETC for his Broadway scenic design.

Shown here are members of the company of *Tiger at the Gates* performed by the MLT in May 1968: Sue Rhines, Irma Johnson, Leon Tranos, Mike Armento, and Rob Winer. This was the group's 46th production.

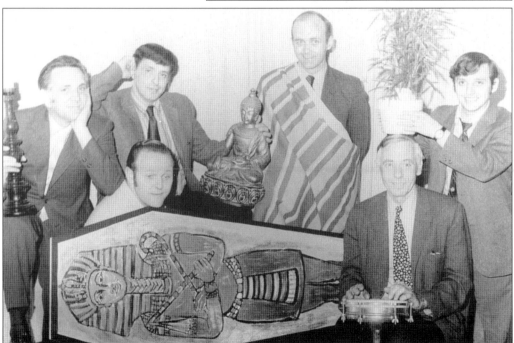

Pictured here is the cast of MLT's May 1971 production of *The Man Who Came to Dinner* having fun posing for a photograph. From left to right are Joe Brophy, Mike Armento, Ron Leger, Mike Geary, Dr. William Healey Sr., and Phil Frasca.

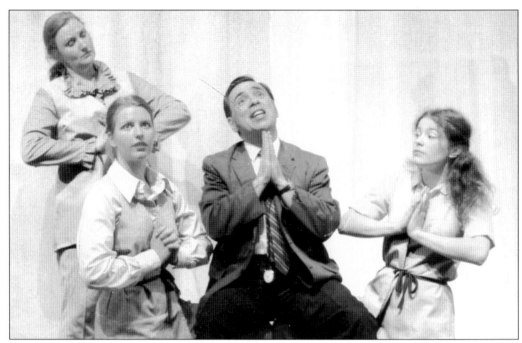

Pictured here is a scene from the 1972 production of *The Pajama Game* starring longtime member Donald Oliver and newcomer Janis Waikel.

New and Experienced In "The Pajama Game"

Don Oliver **Janis Waikel**

Theatre Three has always been proud of their ability to discover new talent and use it in the best manner and yet keep their experienced, recognized actors busy also. They have succeeded on both counts for "The Pajama Game." Newcomer Janis Waikel and experienced Don Oliver will be on stage as Gladys and Hines. Gladys is secretary to the President of the Sleep-Tite Pajama factory and Hines is the well Hines keeps everybody moving. He has a stopwatch which times anything and everything.

Janis is a newcomer to the Acton stage. She worked with the backstage crew to make those fast scene changes in "Cactus Flower." She and her husband, Bob, moved to this area from Illinois and immediately became active in Theatre Three and the Acton Community Center. Janis is presently the secretary to the Board of Directors of the Community Center. Painting, Entertaining, and meeting people are but a few of her many hobbies. Janis is going to be a definite asset to Theatre Three and "The Pajama Game". Look for her name in future productions.

Don Oliver has been with Theatre Three since its beginning and before that, a member of the Little Theatre Workshop since 1955. As a member of Little Theatre, Don has served as President and Treasurer. But his talents extend past the business end and on to the stage.

Don has been active in all phases of theatre. He has directed plays, lighted them, been stage manager, built sets and even worked on props backstage. On stage he has appeared as the General in "Waltz of the Toreadors," Harry Berlin in "Luv" and Oscar in "Odd Couple." Plays are not Dons only interest, he is also active in many musicals. He had roles in "Carnival," "Oklahoma", and his latest role was that of Moonface Martin in "Anything Goes".

Somewhere in this maze of theatre work, Don finds time for his wife, Betty and their five daughters, Kathy, Karen, Cynthia, Susan and Christine. He is a staff electrical engineer at Itek in the Central Research Labs.

Rehearsals are at full speed - singing, dancing, and acting. Ticket sales are at full speed also. From where I stand, "The Pajama Game" looks like it could become the most successful production in the area for quite some time. Successful, not only for Theatre Three, but mostly for the audience. For information and tickets, call Mrs. Barbara Lauritzen at 263-4696. Play dates are April 28, 29, May 5, 6, and 12, 13.

This article is about Donald Oliver and his work over the years with Theatre III. Oliver has been involved with more than 50 shows, mostly plays.

During the 1972 and 1973 seasons, the AFD built a new elevated lighting and sound booth at the rear of the auditorium so moments like this performance by Louise Licklider in the 1972 production of *Lion in Winter* could be seen and heard. Licklider is a past president, director, and actor of the group.

Two long-standing members of the AFD, Jack Sweet and Ernie Stevens, were in the October 1972 production of Neil Simon's *Odd Couple*. During one of the productions, Sweet and Stevens jumped ahead 17 pages yet came back to it and did not miss a beat.

Shown here at the AFD light board is Chris Stevens, son of Ernie Stevens. Chris sat on the board of directors of AFD as an adult.

Chris Stevens, as an adult at festival, stands onstage with Julie Charest and Jack Dacey. Dacey has been associated with the festival for several years and is affectionately known as one of the MIB "Men In Black" as the backstage crew wears all black. Julie Charest has also been a longtime active community theater participant and most recently, in June 2006, was responsible for running the festival at the new venue at the Sorenson Center at Babson College.

Starting in 1932, the Concord Players have staged a production of *Little Women* every 10 years. On May 1, 1932, the *New York Tribune* wrote about their first production on what would have been Louisa May Alcott's 100th birthday. Pictured here is the 1972 cast. A new script by David Fielding Smith was commissioned for the 1992 production and was again used in 2002.

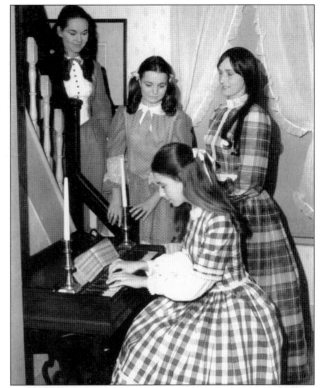

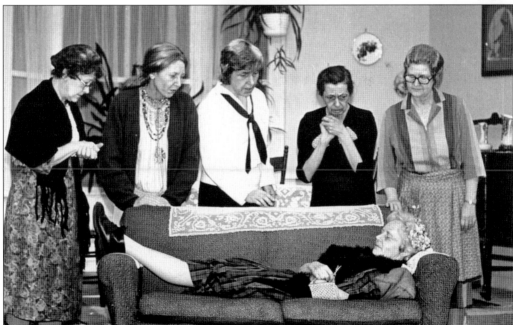

The Vokes Players celebrated its 100th performance with the production of *Bull in a China Shop* by C. B. Gilford in May 1972. Joan Havener directed, and pictured here are Annemarie Strow as Miss Birdie, Barbara Wilson as Miss Lucy, Lois Foersterling as Miss Amantha, Peggy Bruce as Miss Nettie, Jane Hodgkinson as Miss Hildegarde, and Fran Hill as Miss Elizabeth.

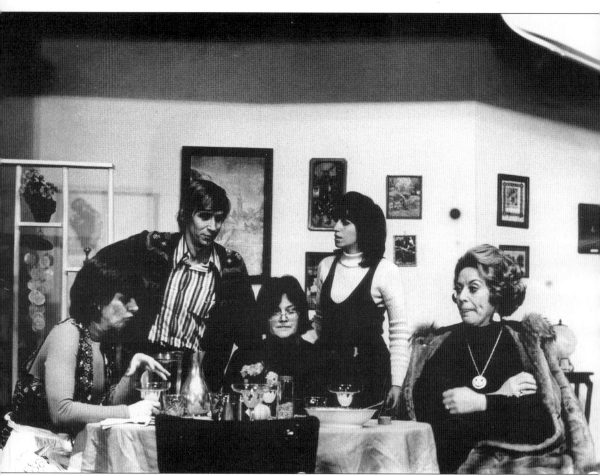

And Miss Reardon Drinks a Little was a NETC Festival entry for the Newton Country Players in 1973. The show was directed by John Deming, and pictured here from left to right around the table are Mikki Krassin as Catherine Reardon, Bob Reed as Bob Stein, Sandy Deming as Anna Reardon, Paula Grossman as Fleur Stein, and Pat Pellows as Ceil Adams.

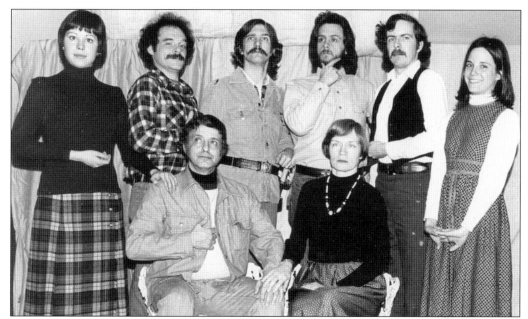

Pictured here is the cast of *Arms and the Man* performed by the MLT in February 1976. From left to right are (first row) Mike Armento and Betsy Gannon; (second row) Bonnie Murphy, Joel Rooks, John Fogle, Kevin McCarthy, unknown, and Andy Collier.

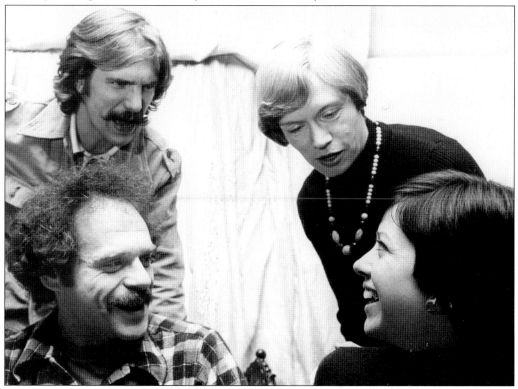

Shown is a lighter moment during a rehearsal of *Arms and the Man* with Joel Rooks (front left), Bonnie Murphy (front right), John Fogle, and Betsy Gannon.

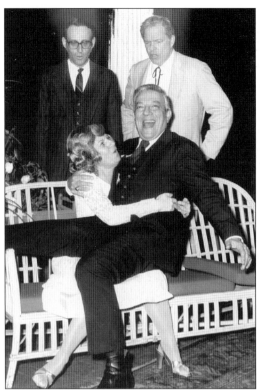

A bit of frivolity takes place between cast members of *Cat on a Hot Tin Roof*, a Newton Country Players production and NETC Festival entry, in 1977. Paul Tines directed the production.

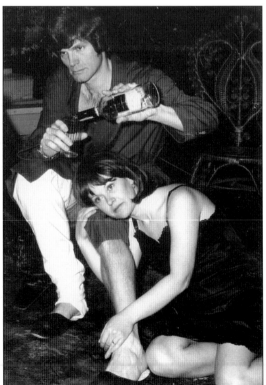

Shown is a more serious moment from *Cat on a Hot Tin Roof* produced by the Newton Country Players in 1977.

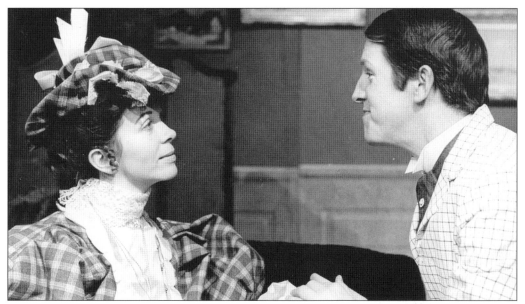

The Importance of Being Earnest was the first show that Dorothy Schecter directed for the Concord Players, December 1977. Thus began a long and wonderfully creative association with not only the Concord Players but also the AFD. In the 1970s, Schecter directed *Ah Wilderness*, which won the Moss Hart Award. She also taught high school drama and directed *Little Women* in 1992 and 2002 among other plays. Pictured here are George Faison, who played John Worthing, and Susan Ellsworth, who played Gwendolyn, in the 1977 production.

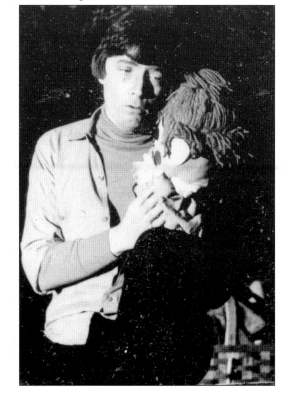

Pictured here is longtime and greatly admired AFD member James Grana in the 1977 *Carnival*. In addition to acting, directing, and serving on the board, Grana had an original play produced by the AFD. Grana is the only one ever to receive five best actor awards at the NETC/Eastern Massachusetts Association of Community Theaters Festival.

Mary Guinan, past president and honorary member of the AFD, is pictured in 1979.

This photograph was taken backstage with the cast and crew of *Witness for the Prosecution*, a 1975 MLT production.

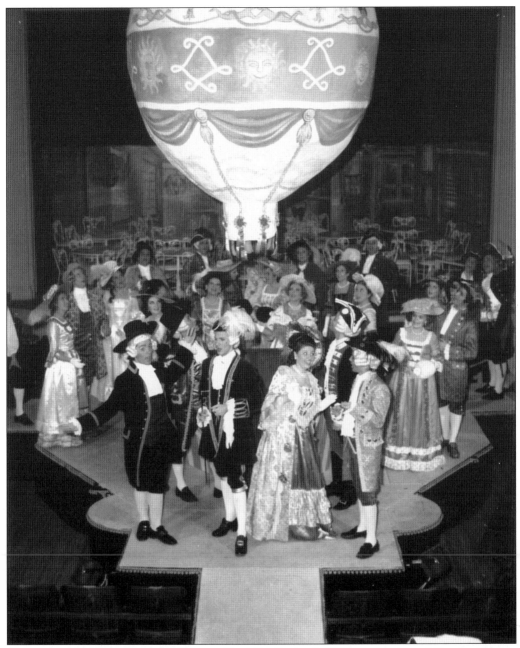

Shown here is the cast of the Weston Friendly Society's 1976 production of *Ben Franklin in Paris*. The production played to sold-out houses and was a town celebration with producers of the original Broadway show in attendance. The writer was originally from Newton and also attended the show. Apparently it had not done well on Broadway. Weston's director moved a number into the finale, and the writer commented after the show "why didn't the Broadway production do that because it would have been a success."

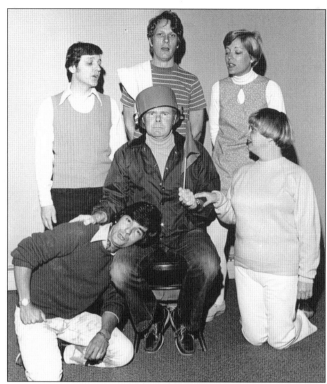

The cast of *You're a Good Man Charlie Brown*, performed by MLT in 1976, consisted of Dick Bartlett as Charlie Brown, Barbara Bibbo as Lucy, Anne C. Smith as Peppermint Patty, Ron Murphy as Linus, Bob Burke as Snoopy, and Phil Frasca as Schroeder. The show originally opened on March 7, 1967, and there was no script. There were 10 songs, a few long scenes, and the goal was to pay tribute to Charles Schulz's immensely human view of the world.

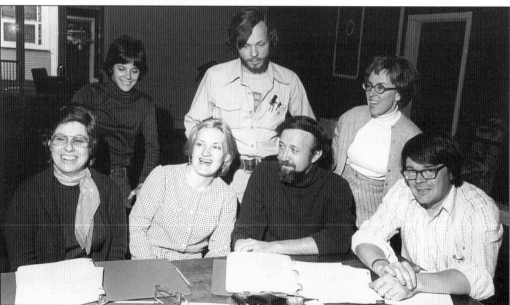

Pictured here is the production crew of *You're a Good Man Charlie Brown* presented by MLT in 1976. Timothy Smith, of Marblehead, was the producer and Carol Weiner, music director for over a dozen MLT musicals, was the music director. While *You're a Good Man Charlie Brown* may be considered a small show involving only a few actors, this is hardly the case. This show toured to Danvers and Peabody along with performing in its home of Marblehead and thus required many hours of rehearsals and planning.

Pictured here is the cover of the Danvers Rotary Club Charities Fund Benefit program for *You're a Good Man Charlie Brown*, presented by the MLT Players on May 8, 1976. Performing shows for charities is what distinguishes many community theaters in the Greater Boston area. Within the program it is written that "A major goal in the organization is to be of assistance to other community organizations, both charitable and social."

Benefit for

Danvers Rotary Club

Charities Fund

YOU'RE A GOOD MAN
CHARLIE BROWN

Presented by

Marblehead Little Theatre Players

MAY 8, 1976

DANVERS HIGH SCHOOL AUDITORIUM

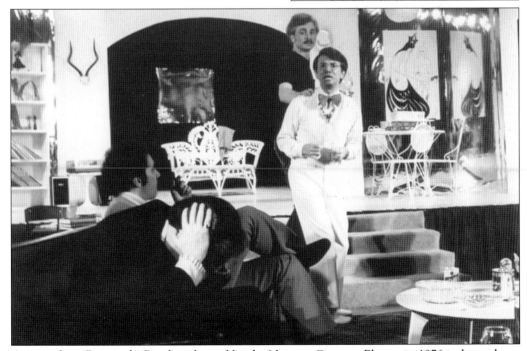

A scene from *Boys in the Band* performed by the Newton Country Players in 1976 is shown here. Newton Country Players, also known in the past as the Country Players of Newton, has been bringing high-quality theater to the community since 1956.

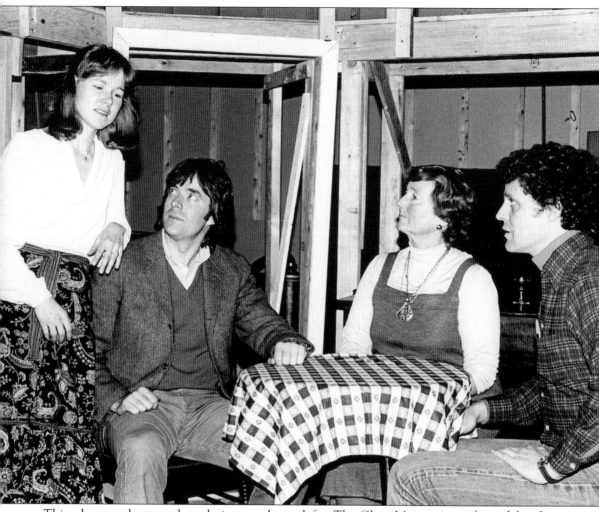

This photograph was taken during a rehearsal for *The Glass Menagerie* performed by the Concord Players in 1979. The production went on to win the prestigious Moss Hart Award. From left to right are Lisa Curtis as Laura, John McAuliffe as Tom, Joan Wood as Amanda, and Jay McManus as Tim.

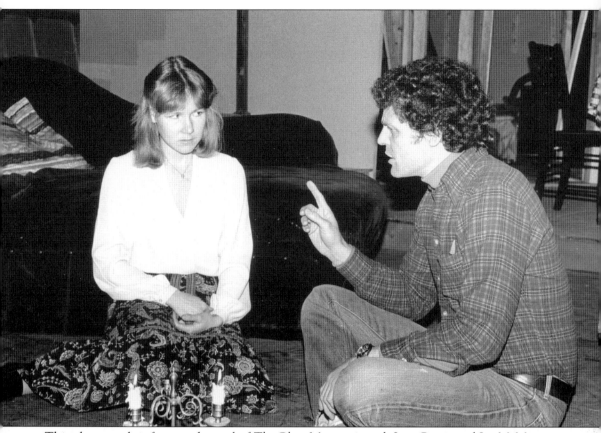

This photograph is from a rehearsal of *The Glass Menagerie* with Lisa Curtis and Jay McManus.

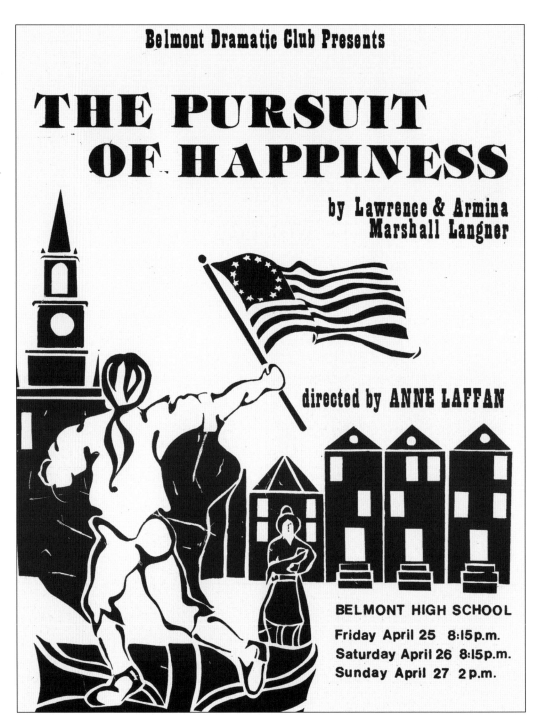

This poster advertises the 1976 bicentennial production of *The Pursuit of Happiness* produced by the Belmont Dramatic Club.

Five

PROFESSIONALISM
COMES INTO FOCUS
1980–PRESENT

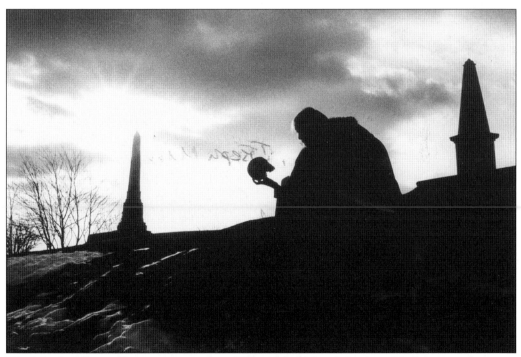

The Mugford Street Players originated in 1975 in Marblehead. In their 30 plus years, the group has staged more than 50 productions at the Unitarian-Universalist Church in Marblehead as well as other local and international venues. Most recently the group has performed at the new Marblehead High School. Shown here is Russ Robbins in a publicity shot for the 1980 production of *Hamlet*.

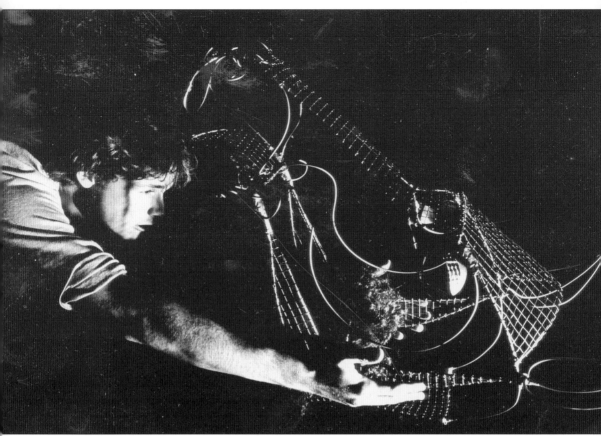

The Mugford Street Players is a long-standing association of theater artists. According to their Web site, the group has no regular schedule of events. Rather, productions occur when sufficient energy and inspiration arise. One such inspired show, *Equus*, took place in 1981 and starred the late Michael Louden. Louden got his start in Marblehead and went on to act professionally in television and film in both New York and Los Angeles.

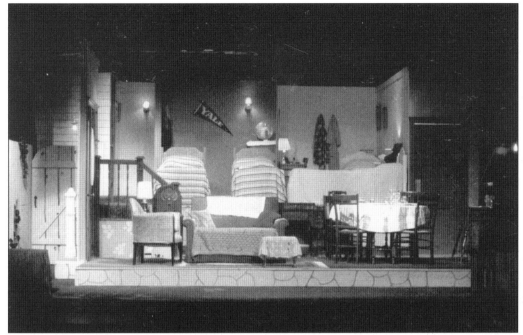

Brighton Beach Memoirs was AFD's 300th production, in October 1987. Pictured here is the set. Nancie Richardson, longtime member of AFD, noted that sets have evolved in a more professional and realistic manner through the years. Whereas sets once had painted moldings, for example, now set designers and builders will use authentic moldings and more realistic scenic touches.

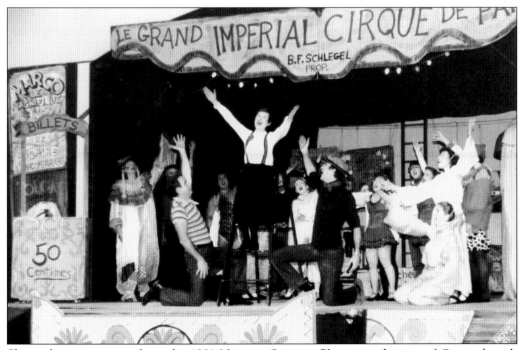

Shown here is a scene from the 1981 Newton Country Players production of *Carnival*, with Linda V. Cardoni, as Lily, and company.

VOKES PLAYERS PRESENT EDWARD ALBEE'S

WHO'S AFRAID OF VIRGINIA WOOLF?

DIRECTED BY R. MICHAEL WRESINSKI

MAY 2, 3, 4,
9, 10, 11,
16, 17, 18
AT 8:00 PM

BEATRICE HERFORD'S VOKES THEATRE
RTE. 20, BOSTON POST ROAD
WAYLAND, MASSACHUSETTS

The Vokes Players presented Edward Albee's *Who's Afraid of Virginia Woolf* from May 2, 1985 to May 18, 1985, and it starred Jack Mayer as George, Betty Scattergood as Martha and, shown here, John Heavy as Nick and Jean Williams as Honey.

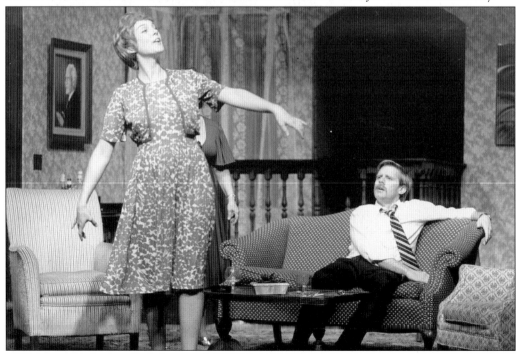

A wonderful result of participating in community theater is the impact it has on young lives. Pictured here is a group of young boys who were portraying the lost boys in the successful 1993 MLT production of *Peter Pan*.

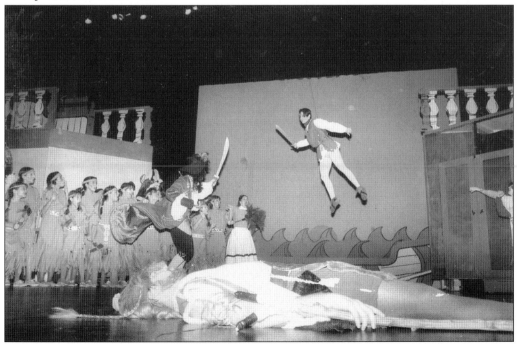

Shown is a scene from MLT's *Peter Pan*, which was performed at the spacious and professional Nelson Aldrich Performing Arts Center. *Peter Pan* was produced by Ginny Morton and Jean Greeley, and Ken Lonergan directed the show.

Participation in community theater fosters friendships and marriages. Shown here are Donald and Nancie Richardson in AFD's production of Sondheim's *Follies* during the 1982–1983 season. *Follies* was directed by James Grana. The Richardsons originally met at the AFD in 1975, were married in 1979, and remain very active with the group. Nancie was asked to perform in this show when the woman who was originally cast, Donna Summer, commenced work as a professional stage manager. Summer was able to perform in one of the shows, however, and in the program, the two women who were friends listed themselves as Donna Richardson.

Shown here are David and Maureen Butler, a married couple who share a common bond of love of theater, in *The Love Course* produced by the Mugford Street Players in 1994.

Pictured here on the right are Dot and Dick Santos, who met through their work in community theater and married, in a scene from AFD's 2004 production of *Titanic: The Musical*.

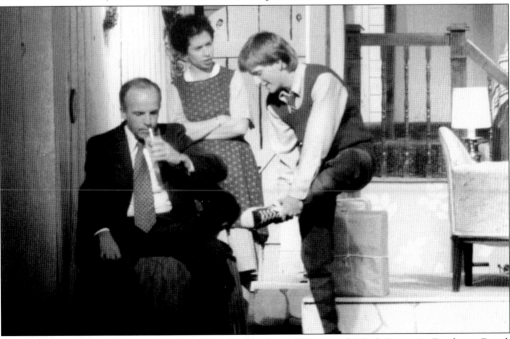

For their 300th production, in October 1987, the AFD staged Neil Simon's *Brighton Beach Memoirs*. Pictured here from left to right are Ronald Brinn, Lila Stromer, and Michael Patterson. Usually parents bring their children to rehearsals and encourage their involvement in community theater, in Michael Patterson's case, he encouraged his parents to get involved once he fell in love with theater arts, and so Robert and Maureen Patterson became active AFD participants.

Pictured here is Michael Patterson from *Brighton Beach Memoirs*, the AFD's 300th production. Patterson is now a professional lighting designer who has worked on Cape Cod and in New York City.

Pictured here are Dave Sheppard and Kathy Campbell of Acme Theater. They are founders of one of the most well-respected and influential community theaters in the Greater Boston area. Acme Theater Productions, based in Maynard, is a non-profit community theater run by volunteers. Team Acme participates in all areas of theater and theater management from selling concessions, operating the soundboard, helping with set changes, working with costumes, and cleaning the theater, among many other duties. The "Misfits," as they have called themselves, have for the past 14 years put on amazingly moving and entertaining productions. Many of these productions have been recognized with awards for acting, singing, directing, stage management, set design, lighting design, costume design, and makeup design.

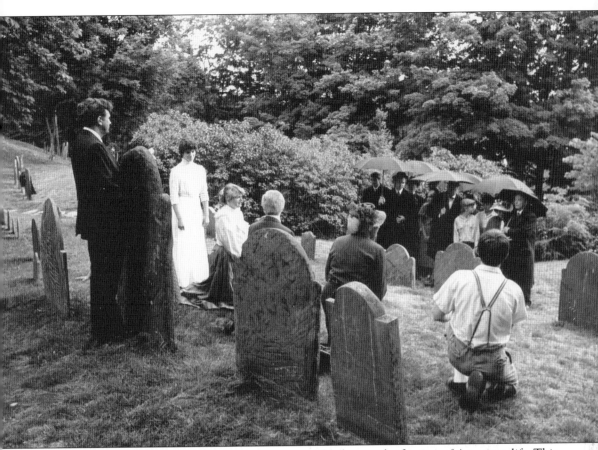

Our Town, by Thornton Wilder, presents a true and fundamental reflection of American life. This play has performed in many theaters across the world. Community theaters in the Greater Boston area have enjoyed taking on the challenge in presenting it in a variety of different ways. The Concord Players have performed *Our Town* twice, in 1985 and again in 2000. At one performance of the 1985 production, shortly before the third act, the actress who played Emily Webb fell sick and the performance was forced to abruptly end after two acts. Shortly thereafter, Thomas Ruggles, of the Concord Players, traveled to Connecticut and petitioned Thornton Wilder's sister for permission to do just the last act of *Our Town* for the public who missed it. She granted the request and so on a Sunday morning in 1985, the third act of *Our Town* was performed in a historic cemetery in Concord. Shown here is a picture of that event.

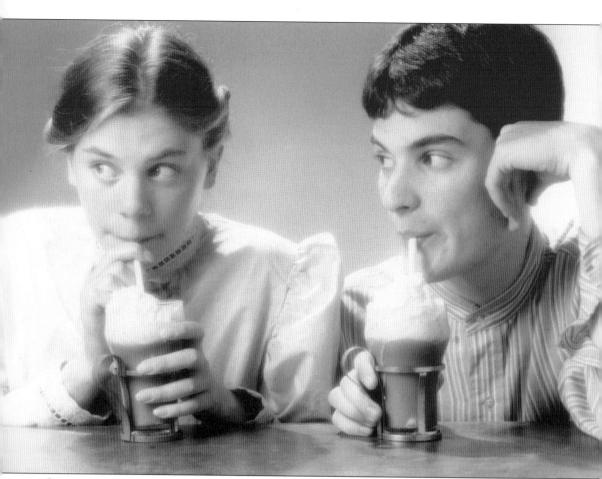

Some communities are blessed with not one, not two, but three theater groups. Marblehead Summer Stage drew from the talents and performance space of the other two groups in town, the MLT and the Mugford Street Players, to form a summer stock type of environment for younger performers to learn from more experienced actors, directors, and technicians. Marblehead Summer Stage's production of *Our Town* in 1990 was performed at the Aldrich Performing Arts Center in Marblehead. Shown here is the soda fountain flashback scene, the centerpiece of the second act, with the author at age 17 playing the role of George Gibbs and Leslie Gamble as Emily Webb.

Those fortunate enough to have known Jack Sweet will always remember him as a remarkably talented and loving man. Sweet performed in community theater productions for many years in the area, and he added professionalism and quality wherever he performed. One time an actor could not perform and Sweet stepped into his role in *On the Razzle* one day before performances were to start. Here is a photograph of the late and superbly talented Sweet in the Concord Players 1987 production of *The Madwoman of Chaillot* by Jean Giraudoux.

In 1973, the Hovey Players constructed a performance space in the basement of the D'Angio Building at 9 Spring Street in Waltham. In 1983, this space was dedicated as the Abbott Memorial Theater in honor of a beloved member, the late Dr. Alden Q. Abbott. The Abbott is a little theater, but that does not reflect the size of the Hovey Players heart nor their talent. Pictured here is the cast of the incredible November 2003 production and EMACT festival award–winning G. R. Point. The cast included Ben Bartolone as Straw, Garrett Blair as Micah, Michael Corbett as Johnston, Claude Del as Deacon, Patrick Flanagan as Zan, Louis Jacques Jr. as Shoulders, Tyler Raynolds as Tito, Jenna Lea Scott as Mama-san, and Keedar Whittle as K. P. Also pictured are director Michelle M. Aguillon, assistant director Leigh Berry, and production assistant Gabrielle M. Aguillon-Hatcher.

Some local theater artists have gone on to find acclaim on a much broader level. Paula Plum has been one of Boston's leading actresses for two decades, and she has movie credits and television experience. Paula was recently honored by the Boston Theatre Critics Association with the Elliot Norton Award for Sustained Excellence (past recipients include Sir Ian McKellen and Julie Harris). She is pictured here in the Mugford Street Players production of *Shirley Valentine* around 1993.

Pictured here is Ronald C. Barker. An actor with the Vokes Players, he has appeared in television and in film and won an Oscar for Scientific/Technical Merit for the invention of the Montage Picture Processor electronic film editing system.

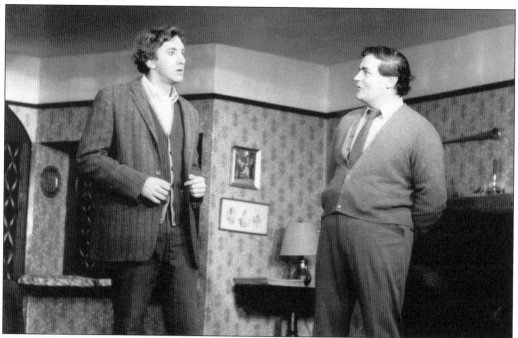

Ronald C. Barker and Kenneth Kiesel are in a scene from the Vokes Players production of *The Norman Conquests* by Alan Ayckburn.

Pictured here is Nancy Travis. Travis has appeared in films such as *The Sisterhood of the Traveling Pants* and *So I Married an Axe Murderer*. In 1979, she appeared in the Vokes Players production of *Charlie's Aunt*.

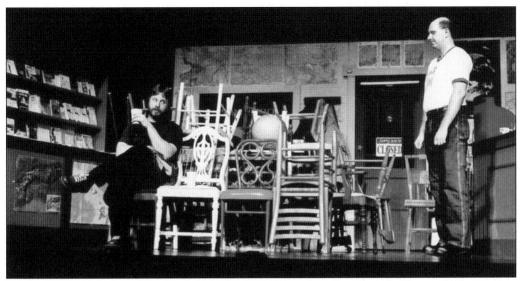

Pictured here is a scene from Acme Theater's 2004 production of *Lonely Planet*. Seated is Tom Berry, and standing is David Fisher. This play competed at the annual EMACT Festival and won. It then went on to compete in the New England Regional Festival and won. It then went on to compete nationally and later internationally. Acme Theater recognizes that community theater is about community. *Lonely Planet* is an example of this axiom because its themes and relevance resound to audiences, and a community theater group like Acme is courageous for taking it on and making it such a success.

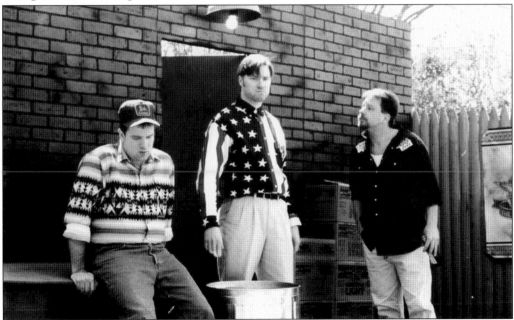

The cast of *Lone Star* is shown here. From left to right are Dan Loya, J. Mark Baumhardt, and Tom Berry. In the spring of 2000, Acme produced a one-act play, *Lone Star*, which was set in west Texas. *Lone Star* was Acme's entry into the EMACT Festival in May 2000, where it was selected as a finalist among a highly talented field of competition. Acme was nominated for several festival awards and received the award for best supporting actor.

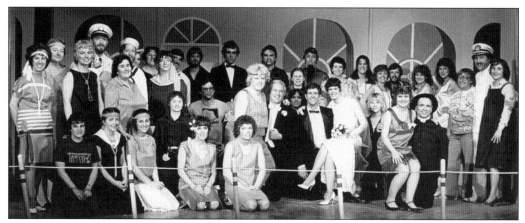

The cast of *Anything Goes* from the Theatre III production is shown in May 1982.

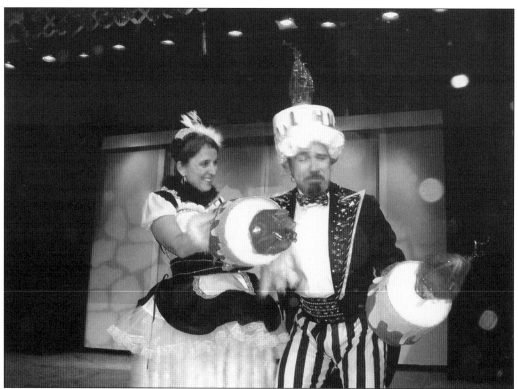

A scene from the 2005 Weston Friendly Society production of *Beauty and the Beast* is shown here. Pictured are Kathy Merlow and Dana Winkler. Presently the Weston Friendly Society is a vibrant theater organization producing at least two musicals each season. Audiences are seated at small tables where they can enjoy snacks, beverages, and camaraderie. Table-hopping at intermission creates a wonderful opportunity to enhance the overall theatrical experience.

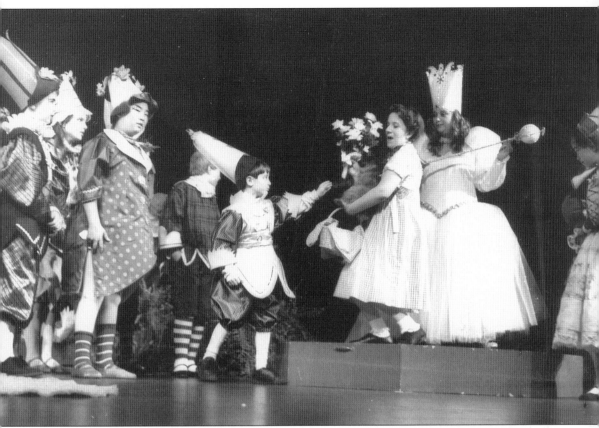

Here is a scene from MLT's *The Wizard of Oz,* which was performed at the Aldrich Performing Arts Center in 1992. During the 1990s, MLT's major project was obtaining a home of its own to stage small productions, rehearse, conduct workshops, and provide space to store and build sets, props, and costumes. The old brick firehouse on School Street, vacant since 1997, was the object of its dream, to have, after 50 years, its own performing space. During the triumphant production of *The King and I* in the fall of 1999, the Marblehead Board of Selectmen awarded the School Street Firehouse to MLT. In 2006, MLT enjoyed its first production in the firehouse, appropriately, *Our Town.*

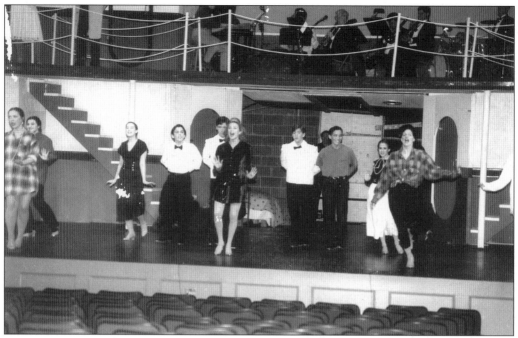

This photograph was taken during a rehearsal of *Anything Goes*, a 1995 MLT production.

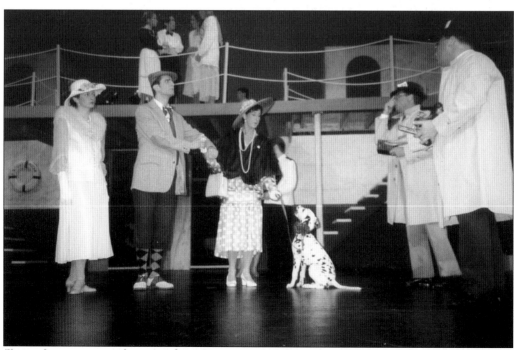

Shown here is a scene from *Anything Goes*, a 1995 MLT production. Animals on stage are always a treat for audiences but can be quite an actor's challenge.

The Quannapowitt Players actors and crew are getting into their places. They are pictured here looking up from the pit at the Brandeis stage during the festival in May 1986. The pit can rise and descend, and several groups through the years have used it as part of their competition pieces. In 1986, the Quannapowitt Players brought *Motif #3* to festival.

Tom Berry enters the laundromat in Acme Theater's 1998 production of *Stiff Cuffs*. Acme's production of *Stiff Cuffs*, a romantic comedy set in a laundromat on New Year's Eve, was selected as best production of the 1998 EMACT Festival. In addition, the show was awarded best director (Dave Sheppard) and earned four other award nominations. In August 1998, *Stiff Cuffs* performed at the New England Theater Festival in Springfield and won best production. Acme also earned the best director, best actor, and best actress awards and was nominated for two other awards. With the New England regional win, Acme earned the right to enter the American Association of Community Theatre National Theater Competition in Memphis in July 1999.

The Wellesley Players was formed in 1925 as the Wellesley Village Players. Performances were held in the community hall of the Wellesley Village Church. The group has produced over 150 productions, and they currently present two plays a year at the Sorenson Center at Babson College. In 2003, the Wellesley Players were the first community group in the Greater Boston area to stage a production of *The Guys* by Anne Nelson, a powerful show about a New York City firefighter who has to write eulogies for eight of his men caught in the collapse of the Twin Towers. Pictured here is the author in the EMACT festival production, which went on to the finals.

ACROSS AMERICA, PEOPLE ARE DISCOVERING SOMETHING WONDERFUL. *THEIR HERITAGE.*

Arcadia Publishing is the leading local history publisher in the United States. With more than 3,000 titles in print and hundreds of new titles released every year, Arcadia has extensive specialized experience chronicling the history of communities and celebrating America's hidden stories, bringing to life the people, places, and events from the past. To discover the history of other communities across the nation, please visit:

www.arcadiapublishing.com

Customized search tools allow you to find regional history books about the town where you grew up, the cities where your friends and family live, the town where your parents met, or even that retirement spot you've been dreaming about.

The annual NETC, now EMACT, community theater drama festival has been a favorite event for 53 years. For more than half a century, this festival has enabled community theaters to come together to celebrate and honor the work of the previous year. Whether from the audience's point of view, as shown in this picture, or from the actor's perspective, one thing is certain, the curtain will always rise on Greater Boston community theater.